Mad about Painting

Mad about Painting
Katsushika Hokusai

Selected and translated by Ryoko Matsuba

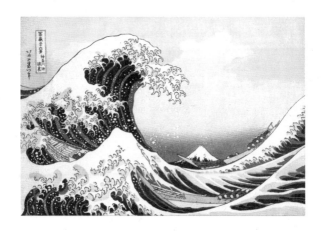

Katsushika Hokusai, *Under the Wave off Kanagawa*, c. 1830–1832.
Woodblock print; ink and color on paper, 10⅛ × 14⅞ inches |
25.7 × 37.9 cm

Contents

Introduction

Ryoko Matsuba

Katsushika Hokusai enjoyed the longest career of any nineteenth-century Japanese artist. Though he reached the age of ninety[1] at a time when the average life expectancy was half that, he was never truly satisfied with himself as an artist. Hokusai's final words, recorded from his deathbed, were, "If heaven will afford me five more years of life, then I'll manage to become a true artist." Hokusai's drive to master the art of painting is evident in his prolific output: between the years of 1770 and 1849, the artist worked in three media—print, painting, and book illustration—and produced thousands of works in total.

Hokusai's *Under the Wave off Kanagawa* (p. 5), commonly known as *The Great Wave*, has become one of the best-known Japanese artworks in the world. Produced in the early 1830s, when Hokusai was in his seventies, this work was part of *Thirty-Six Views of Mount Fuji*, Hokusai's most ambitious large-format color-print series. Despite the popularity of his color woodblock prints, book illustration dominated Hokusai's printed output.

Throughout his career, Hokusai partnered with block cutters and printers to disseminate his unique artistic vision through books and manuals, first to a national audience, and then, posthumously, to a global audience. The texts gathered in this new volume, many translated into English for the first time, shed light on the artist's approach to painting and capture his commitment to passing on the craft he honed over a lifetime. The selected prefaces, postscripts, and advertisements

from Hokusai's illustrated books of the 1820s and '30s, including *Modern Designs for Combs and Tobacco Pipes*, *One Hundred Views of Mount Fuji*, and *Katsushika's New Pattern Book*, introduce Hokusai's artistic vision in his own words and those of his peers. Through entries dedicated to coloring plants, animals, and everyday objects, selected from Hokusai's last painting manual, *All about Painting in Color*, a clear picture of Hokusai as a teacher of amateur artists—even children—emerges. Published the year before his death, the entries are accompanied by some of Hokusai's last illustrations, a number of which are reproduced in this volume. Finally, the contemporary Japanese artist Manabu Ikeda reflects on how Hokusai's legacy has endured to the present day.

Hokusai's *Modern Designs for Combs and Tobacco Pipes*, published in 1823, is full of intricate and imaginative designs for craftspeople to copy. The book was small enough in size—a format sometimes called *shūchinbon* (unusual books for sleeves)—that it could be carried in a kimono sleeve. The fine details in the volume made it a challenge for the woodblock cutters to prepare printing blocks from Hokusai's meticulously rendered block-ready drawings. The process, which involves carefully carving through finely detailed illustrations glued onto prepared wooden blocks, destroys the drawings. The renowned block cutter Egawa Tomekichi rose to the occasion, fully realizing Hokusai's exacting demands for total accuracy and precision. Through the project, Egawa and his studio gained Hokusai's trust and went

on to collaborate with the artist on a number of other publications.

The foreword to *Modern Designs for Combs and Tobacco Pipes*, written by Ryūtei Tanehiko, is the first text presented here, followed by the preface, written by Hokusai himself. Tanehiko's writing style is highly learned, characterized by frequent references to the classics, while Hokusai directly addresses the craftspeople using his book. Also included here is the poetic afterword to the manual, written by the *kyōka* (crazy verse) poet Shakuyakutei Nagane. Together, these texts ground Hokusai's designs in history while also ensuring they remain accessible to those putting his volume to use. The publisher Nishimuraya Yohachi's catalogue of Hokusai's other illustrated books and a print is also translated here. As most of the titles in this listing are unknown and were likely never published, it provides valuable insight into Hokusai's future plans with the publisher.

Modern Designs for Combs and Tobacco Pipes was reprinted in the 1880s and distributed across Japan. Released many years after the artist's death, this second edition served as a model for the lacquer artists who were still using Hokusai's designs. Both the original and reprinted editions of the volume were also exported to the Western market. The British artist Thomas W. Cutler reproduced a few of Hokusai's designs in his book *A Grammar of Japanese Ornament and Design*, published in 1880 by B. T. Batsford. This is an early example of artists and craftspeople outside of Japan adopting Hokusai's designs.

More than a decade after *Modern Designs for Combs and Tobacco Pipes* first appeared, Hokusai's masterpiece, *One Hundred Views of Mount Fuji*, was released.[2] The first two volumes, printed in 1834 and 1835, respectively, closely followed Hokusai's popular *Thirty-Six Views of Mount Fuji* print series. Because the quality of the blocks cut for books was much higher than that of the blocks cut for single-sheet prints, this was Hokusai's chance to continue his exploration of the mountain in greater detail. Higuchi Niyō[3] discussed the quality difference between print and illustrated books in an essay published in 1932:

> The block cutters, particularly those who worked on Hokusai's picture books, were also skilled in cutting texts. They were contracted directly by the publishers to wield their blades.... In general, the quality of the block cutting for color prints was not particularly high. The quality of the block cutting for the images even in the poorer examples of picture books and *yomihon* (serious illustrated fiction) is superior to that encountered in color prints.[4]

It was the success of Hokusai's print series that enabled the artist and his publisher to take on the cost of this higher-quality book project, for which Hokusai could again rely on Egawa and his studio to faithfully cut the designs into printing blocks.

Though the publisher Nishimuraya stopped operating around 1836, a third, undated[5] volume of *One Hun-*

dred Views of Mount Fuji was eventually released by Eir-
akuya Tōshirō, the Nagoya-based publishing firm that
took over printing Hokusai's books. The prefaces and
postscripts from these three volumes are gathered here.
The literary prefaces to the first two volumes, written
by Ryūtei Tanehiko and Rozankō, signal the quality and
seriousness of the images Hokusai produced. The art-
ist's postscript expresses with great force Hokusai's ar-
tistic mission. In his quest for mastery, Hokusai was un-
shakable in the belief that day by day and year over year
his technical skill would increase. His greatest desire
was to live to be one hundred years old, so he could be-
come a true artist. Hokusai died when he was ninety, and
his statement of this wish, which he wrote when he was
seventy-five, signals that he felt he was just beginning
his true artistic career.

In 1836, Hokusai released *Katsushika's New Pattern
Book* with Kobayashi Shinbei's publishing firm, Sūzanbō.
Egawa once again cut the blocks. In the pattern book,
Hokusai offers detailed architectural drawings that set
out roof shapes, pillar assembly, temple bell decoration,
and instructions to build a pontoon bridge. Through-
out the volume, Hokusai notes that he abbreviated his
designs to avoid creating too much work for the block
cutters. This appears to be a confession that, in the past,
his block-ready drawings were too detailed.

Included here are Hokusai's preface and postscript
from *Katsushika's New Pattern Book*. In his preface, Hoku-
sai alludes to the creative philosophy that drives him

Title page from the first volume of Katsushika Hokusai's *All about Painting in Color* (1848)

as an artist and a teacher—that everything in creation has a role, and it is only through a deep understanding of these roles that artists can produce work with integrity. In contrast, the postscript, which relays an exchange with a guest who found the artist's work too detailed, expresses Hokusai's resentment toward the publishing process at large. (Though we do not know who his guest was, it may have been a publisher reluctant to undertake the high block-cutting cost necessitated by the artist's detailed drawings.)

Soon after, in the late 1830s, Hokusai's print production declined significantly. He did not produce another large series of single-sheet prints on the scale of *Thirty-Six Views of Mount Fuji*, and he published few illustrated books after 1837. Painting dominated Hokusai's output in the final decade of his life, and yet, in his last years, he embarked on the ambitious illustrated manual *All about Painting in Color*. The first images (pp. 14 and 44) clearly reveal the aged artist's shaky lines. Here, the block cutter faithfully reproduced the long lines Hokusai had broken into smaller segments, a precise expression of his "brush power" in his final years. Despite his age, Hokusai was determined to transmit his understanding of Japanese brush painting to amateur artists. The volumes explain the techniques Hokusai employed when coloring flowers, animals and mythical creatures, landscapes, kimono patterns, and housewares, along with instructions for using or creating pigments. Interestingly, Hokusai rarely explains how to draw his subject matter.

Instead, he repeatedly stresses the need to color accurately, noting that if the color is wrong, the subject ceases to be itself.

Throughout his instructions, Hokusai frequently notes techniques he plans to explain later, but in some instances the promised explanation never appears.[6] These details would have followed in one of the two additional unpublished volumes announced on the last page of the first book. Hokusai clearly had an overview of the entire series in his mind, but he died before he was able to complete the project. His role was curtailed even between the two published volumes, resulting in clear differences between the books. Texts in the first volume are slightly angular and very legible, much like the texts in *Katsushika's New Pattern Book*. The text in the second volume is written in a more vertical style that is long and flowing and, at times, difficult to read. The second volume also includes editorial errors, such as repeated text entries[7] and misordered pages. Even the quality of Hokusai's line differs. Though all the designs are faithful to Hokusai's style, some of the brushstrokes in the second volume lack spontaneity, and they appear to have been meticulously (and a bit stiffly) copied by another hand. It seems that, in his last year of life, Hokusai was not able to edit his final text, nor was he able to produce all the block-ready drawings for the volume. The entries reproduced here uniquely capture Hokusai's creative worldview and a lifetime of attention to detail, all constantly sharpened by the pursuit of becoming a true artist.

In the late nineteenth century, when trade opened between Japan and the West, Hokusai's prints quickly found an international market. The advertisements reproduced here illustrate Hokusai's posthumous popularity outside of Japan. Most immediately appealing to international audiences were his single-sheet large-format landscape prints. Though most of these collectors would never experience the scenes in person, the emotions these works convey are universal. Artists such as James Abbott McNeill Whistler and Claude Monet celebrated Hokusai's *Great Wave*; Claude Debussy took inspiration from the work for his symphonic sketches dedicated to the sea; and in 1888 Vincent van Gogh wrote about it in a letter to his brother Theo:

> Hokusai makes you cry out the same thing—but in his case with his *lines*, his *drawing*, since in your letter you say to yourself: these waves are *claws*, the boat is caught in them, you can feel it. Ah well, if we made the color very correct or the drawing very correct, we wouldn't create those emotions.[8]

Today, even people who do not know Hokusai's name equate the iconic *Great Wave* with Japan, and artists are still responding to his work. In 2008, the Japanese artist Manabu Ikeda produced *Foretoken* (p. 18), a large painting with a composition similar to Hokusai's *Great Wave*. Instead of showing the wonders of nature, Ikeda's wave swallows up everyday life in an all-too-familiar scene

Manabu Ikeda, *Foretoken*, 2008. Pen and acrylic ink on paper mounted on board, 74⅞ × 133⅞ inches | 190 × 340 cm

of natural and man-made devastation. Though Ikeda didn't set out to reference Hokusai's *Great Wave*, he says his work on *Foretoken* was led by Hokusai's spirit.[9] Perhaps Hokusai's vivid imagination, combined with his meticulous attention to detail and subtle use of color, has been transferred to this contemporary artist. Although Hokusai did not live to be one hundred years old, the works of his final years continue to inspire. The translations gathered in this volume reveal Hokusai's astonishing insights into the world around us and, if nothing else, fulfill the artist's hope that his words will "serve as proof that [he] tottered along on the path of painting."[10]

1 Because Hokusai frequently references his own age in his writing, throughout this volume, his age is calculated according to the premodern lunar calendar. In Japan at the time, people were considered one year old at birth, and their age would increase with each lunar new year. According to the Western calendar, Hokusai died at the age of eighty-eight.

2 In 1880, an early English translation of the preface was published by the former British naval surgeon Frederick Victor Dickins. See *Collected Works of Frederick Victor Dickins* (Bristol: Ganesha; Tokyo: Edition Synapse, 1999). More recently, the historian Henry D. Smith II published *Hokusai: One Hundred Views of Mount Fuji* (New York: George Braziller, 1988), complete with a full set of illustrations. The translation of *One Hundred Views of Mount Fuji* in this volume was influenced by Smith's work.

3 Higuchi Niyō (1863–1930) first worked as an ukiyo-e artist and later became a journalist.

4 Higuchi Niyō, "Ukiyo-e hanga no kenkyū," in *Nihon oyobi Nihonjin* (Japan and Japanese), 1931–1932. Reprint, Tokyo: Seishōdō, 1983.

5 In his preface, the writer Shippōsanka Rōjin Shōryū notes, "I hear that the old man has passed the age of ninety," which suggests the third volume was published around 1849.

6 Two albums of drawings recently discovered at The Museum of Fine Arts, Boston, titled *Saishikitsū shūran* (Collection of Drawings from Hokusai's *Saishikitsū*), appear to contain manuscript copies of the explanations missing from the two printed volumes of *All about Painting in Color*. These albums, dated 1855 and 1856, may have been assembled by Hokusai's pupil Hokuga (died 1856).

7 Duplicated sentences were cut from the translations in this volume.

8 Van Gogh is referencing the critic Paul Mantz's response to Eugène Delacroix's *Christ Asleep during the Tempest*: "I did not know that one could be so terrifying with blue and green." Vincent van Gogh to Theo van Gogh, September 8, 1888. Van Gogh Museum, letter 676, http://vangoghletters.org/vg/letters/let676/letter.html.

9 See p. 154 in this volume.

10 See p. 41 in this volume.

Modern Designs for Combs and Tobacco Pipes

The sacred *tsuma* comb of *yutsu* and the small boxwood comb are equally balanced mainstays [of comb craft in Japan], like the founding female and male deities.[1] Their origin lies in the plum-scented age of the ancient gods. The *hoso-gushi* (thin comb) and *sashi-gushi* (ornament comb) were first discussed in [Minamoto no] Shitagō's *wamyō* dictionary,[2] as is well-known. The Kamakura-period *masago* comb[3] has been handed down through a stream of generations. *Sudare* combs of the Muromachi palace still retain the fragrance from the hair of the handsome men who wore them. The domestic products of Nagato province in Satsuma became famous during the Keichō era, and the *marumune iori* comb[4] gained renown during the Genroku period.

Since then, many innovations have been introduced, such as the *asahi* (dawn) and *mikazuki* (crescent moon) combs. People have attempted to create new comb designs in every way possible, whether carved or lacquered, employing the utmost care in their production. A book containing designs [for these artisans to copy] is nowhere to be found. For this reason, Eijudō[5] commissioned Iitsu, the former Hokusai, to produce various designs [for combs and] tobacco pipes. Titled *Modern Designs for Combs and Tobacco Pipes*, the volumes aim at assisting the many people who make these things.

By Tanehiko, proprietor of Ryūtei, in the eighth month of 1823[6]

Every so often in the production of tools and utensils, something square-shaped, when the times change, will be made circular, and at once everybody finds it highly admirable. This is known as fashion, and it is particularly true of the shapes of the combs and hairpins loved by young girls. For that reason, designs based on the way things are made today will, in time, come to suffer the consequences [of changing taste]. Accordingly, without regard to circular or square shapes, large or small, I decided it would be helpful to present only the pictures that adorn these items.

Some motifs in this volume can be applied to the reverse side of the comb, forming continuous pictures from the front to the back, such that the plants and trees, insects and fish wrap around both sides. The crescent moon shape popular today has an extremely narrow ridge, but if ridges should widen according to future tastes, it would require little effort to enlarge the designs. Moreover, it is easy to reduce the width in order to accommodate the number of teeth in a comb, but adding width is difficult. On that account I have provided supplementary notes beside the designs. Please pay attention [to those notations] when you look at [this book].

By the former Hokusai, who has changed his name to Katsushika Iitsu

Calligraphy is like hearing a resonant voice, and painting is like seeing a dramatic gesture.

A picture is worth a thousand words.

How clever were the ancients, who compiled illustrated editions of the classics, bequeathing picture scrolls to us?

Here we have designs of combs and pipes from the past to the present, and formulas for inlay and lacquer, in this two-part illustrated book titled *Modern Designs for Combs and Tobacco Pipes*.

If you apply yourself to the study of this book, you will not be limited by its content. Rather, you will be able to draw freely from its lessons in many ways.

Shakuyakutei shujin,[7] Spring 1823

CATALOGUE OF PUBLICATIONS BY HOKUSAI ISSUED BY EIJUDŌ

Master Iitsu's Painting Album (*Iitsu-sensei nikuhitsu gajō*)

These illustrations are not printed from cut blocks; they are original paintings from the brush of Master Iitsu, the

former Hokusai. However deep in the provinces you may live, if you acquire and study this album, it will be as though you have begun training under the master himself.

Master Iitsu's Album of Tasty Morsels (Iitsu-sensei keiroku gafu)

This title presents things that ordinary artists, since the ancient times, have had difficulty drawing, including curious customs seen and heard since around 1819, birds and animals, plants, utensils, and aspects of astronomy and geography—each compiled and published in a separate volume.

Eight Forms of Mount Fuji (Fugaku hattei)

In this volume, the artist's brush captures how scenery changes in accordance with the shifting seasons and weather, from rain to shine, with wind, snow, and mist.

One Hundred Bridges at a Glance (Hyakkyō ichiran)

Single-sheet print
A useful guide to illustrating landscapes and the way bridge construction varies among the capital and the provinces, depending on geographic location.

Illustrations of Wind and Rain, Frost and Snow (Gazu fū-u sōsetu hen)

This book depicts landscapes, plants, people, animals, wind and rain, and frost and snow, and also explains the concept of using strengths and weights [when drawing pictures].

One Hundred Palaces at a Glance (Ichiran hyakkyūshitsu)

Single-sheet print

Translator's Notes

1 The *tsuma* comb is a legendary comb mentioned in the *Ancient Records of Japanese History* (*Kojiki*), which was compiled in the early eighth century. *Yutsu* refers to "large numbers," suggesting a comb with a large number of teeth. *Tsuma-gushi*, the Japanese word for the *tsuma* comb, usually refers to a claw-shaped comb. However, since the word "tsuma" also means "spouse," here it is intended as a pun on the female and male gods who created the country.

2 Minamoto no Shitagō (911–983), a *waka* poet and scholar in the middle Heian period, edited an early Chinese-Japanese dictionary titled *Wamyōruijushō*, circa 934.

3 In the early Kamakura period (1185–1333), Hōjō Masako (1157–1225), who had significant power over the shogunal government, made fashionable the *Masako-gata* (Masako-shaped) comb. This shape remained popular into the early modern period. The author here writes *masago*, meaning "the sand of a beach," which is a pun on Masako's name.

4 *Marumune* refers to a round-shaped comb. An *iori-gata* comb is an ornamental comb bearing a *mokkō* (Japanese quince) crest or mark.

5 Eijudō is the publishing house in Edo (present-day Tokyo) founded by Nishimuraya Yohachi in the middle Edo period. In the 1830s, eight to nine years after *Modern Designs for Combs and Tobacco Pipes* was published, Nishimuraya produced Hokusai's most iconic print series, *Thirty-Six Views of Mount Fuji*, which includes *The Great Wave* and *The Red Fuji*.

6 Ryūtei Tanehiko (1783–1842), born into a samurai family, was a popular writer of the later Edo period. He produced numerous illustrated serial novels beginning in the 1810s. Hokusai produced illustrations for some of Tanehiko's books.

7 Shakuyakutei Nagane (1767–1845) was a popular writer and *kyōka* (crazy verse) poet of the later Edo period. He was also known as Honami Kōetsu VII, Hōseidō Kisanji II, and Asagi Uranari II.

One Hundred Views of Mount Fuji

Keichū's *One Hundred Verses on Fuji*[1] presents itself like
a jutting peak, while Tōchō's "One Hundred Haiku on
Fuji"[2] conceals itself behind iridescent clouds. In this
volume, the old man formerly known as Hokusai has
newly illustrated one hundred aspects of Mount Fuji.
This mountain stands alone, towering above the com-
mon peaks. The old man's pictures likewise stand alone,
exalted beyond [Mount Fuji's] twelve thousand feet. His
painting albums are treasured by a great number of peo-
ple across the realm, certainly not only within the fifteen
provinces, with their magnificent scenery, that surround
Mount Fuji. The *Hizōshō*[3] records the ten different
names for Mount Fuji, and the master, too, has changed
his name frequently—his names must number ten at
least. There may be some sort of connection here, since
the master has admired the peak for many years.

Perhaps [Hokusai] considered depicting the views
looking up from Tago Bay or across from Cape Miho to
be as conventional as the oft-repeated phrases, such as
"a cloudless moon" or "cherry blossoms at their peak."[4]
He has carried his walking stick far beyond, to Fujimi-
gahara, and stopped his sedan chair at Shiomizaka.[5] He
has glimpsed the slopes through willow branches and
gazed up at the peak through trembling stalks of rice.
He has traced true views of the vast ocean breaking in
rough waves against the rocks, of valleys filled with white
clouds, of ascents through winding mountain passes

and descents through perilous ways—his spirit resides in this volume. This book will stand out as a pinnacle among the picture books proliferating in the world like so many low hills. One might even say it is in no way inferior to the high priest [Keichū's] *One Hundred Verses on Fuji*.

Respectfully, Ryūtei Tanehiko, the third month of 1834

HOKUSAI'S POSTSCRIPT FROM THE FIRST VOLUME

Since I was six years old, I have had a penchant for tracing the shapes of things, and since my half centenary, I have produced numerous pictures and illustrations, but nothing I drew before the age of seventy really counts for much. By age seventy-three, I had acquired some understanding of the framework of birds, animals, insects, and fish, and the beginnings of plants and trees. Could it be that, in this way, by age eighty, I will be making even greater progress, and by age ninety, penetrating the inner mysteries [of painting], and by age one hundred, become truly peerless? And so it may be that when I am into my hundred and tens, each dot and each brushstroke will seem to have a life of its own. I pray that long-lived men of virtue will bear witness that my words are not wild talk.

PREFACE FROM THE SECOND VOLUME

Fuji the mountain: in shape, like a cut jewel; in color, like polished silver; having neither front nor back; neither towering nor leaning; flawless on all sides, like a lotus rising from the water; grandly straddling the summits of common peaks: it crowns the realm. When the [dawn] sun shines red above the horizon, it appears pure white, and as the sun sets, it turns blue and green. Morning and evening, its colors vary; near and far, its outlook differs. Through spring haze and autumn breeze, and in the flickering light of clouds and mist, its scenery changes in a hundred ways. Master Hokusai has drawn one hundred views, and his exquisite skill truly approaches [the status of] an ever-changing wonder. Look at these pictures, for they must be seen.

Rozankō,[6] the first month of 1846

PREFACE FROM THE THIRD VOLUME

While Minsetsu's *One Hundred Fujis*[7] is conventionally illustrated, old man Hokusai's *One Hundred Views of Mount Fuji* is nothing short of eccentric. Using his vigorous brush, the old man has roused the peak of Fuji out of paper and ink. He has managed to depict it from every direction, front and back, in ways that are extremely wonderful and clear. I hear that the old man has passed the

age of ninety,[8] but still his sight and hearing are the same as when he was young, as if he somehow obtained the elixir of immortality from the illustrious mountain itself. The third volume [of *One Hundred Views of Mount Fuji*] has been cut into blocks for printing, and Gochō,[9] the proprietor of Tōhekidō, asked me for a preface, so I wrote this text to share my deep admiration [for the book].

Shippōsanka Rōjin Shōryū [10]

Translator's Notes

1 Keichū, *Ei Fujiyama hyakushu waka*, published in 1782.

2 Tōchō, "Tōko fuji hyakku," in *Fujimōde*, published in 1692. This publication commemorates the author's ascent of Mount Fuji.

3 A poetry book compiled by Ōkōchi Mitsune in the Muromachi period (1336–1573).

4 These famous phrases appear in *The Harvest of Leisure* (*Tsurezuregusa*) by Yoshida Kenkō (c. 1283–1350).

5 There is a similar sentence in the preface to Minsetsu's *One Hundred Fujis* (*Hyakufuji*), published in 1767, where Minsetsu "stood on the walking stick on Tago Bay and stopped a horse at Shiomizaka."

6 The preface was signed "Rozankō," followed by seals that read "Shuseian" and "Satoi." If these seals indicate the author's name, it may be Satoi Takamasa (1799–1866), who was a *kokugaku* scholar, an academic devoted to classical Japanese learning rather than classical literature imported from China.

7 *One Hundred Fujis* was published in 1767.

8 Though the original publication date is unknown, this suggests that the third volume was published after 1849, when Hokusai reached his ninetieth year.

9 Eirakuya Tōshirō III (1796–1858) was also a poet, who wrote under the name Gochō.

10 Though the text is signed "Shippōsanka Rōjin Shōryū," Shippōsanka indicates that the author was based in Nagoya, the same city as the book's publisher. Other details about the author of this preface are unknown.

Katsushika's New Pattern Book

People have been depicting the physical appearance of things since ancient times: heaven with its sun, moon, and stars, and the earth with its mountains, forests, fish, and birds. We drew a figure resembling a gate, and then read it to mean "house" or pronounce it as "countryside." Didn't shapes develop first and their meanings accrue later? That is exactly the case with the origins of *tensho* (seal script), the oldest of Chinese characters. So why can't self-proclaimed artists draw palaces and monasteries, in their rich diversity, with any skill?

"Pattern books" are a long-standing genre, and a publisher asked me to draw one of my own. The traditional pattern book teaches the principles of constructing buildings, as written by carpenters who want to hand down techniques and measurements. This new pattern book seeks to present a complete account of the physical appearance of things for the purpose of drawing. You could describe this book as a cat masquerading as a tiger, or a black kite squaring off against falcons. Even so, a black kite knows whether it will rain or shine and caws accordingly, and a cat will always outdo a tiger at catching mice. For every flaw, there is a strength. This rule applies to all things in creation. If, on occasion, you find this book useful, I will feel only pride that it has been one gem in the Crystal Mountains, one branch in a forest of cinnamon trees.

Related by Manji, the old man mad about painting, early spring 1836
Transcribed by Tōsai Moriyoshi[1]

A guest came to me and complained, "Many people say your drawing style is too intricate and your pictures are too detailed. You should change that."

I replied, "The wise person's wisdom lies in not taking reading seriously. Such a person only acknowledges elegant and refined writing and seeks to keep up-to-date with every trend. If you use such superficially acquired knowledge, you can make a name for yourself. Without proficiency [gained through solid practice], your skills will deteriorate as you age. I am lucky enough to be illiterate, so I am not bound by the old ways. However, I do regret my poor performance last year, and I am ashamed of what I did yesterday. I am a solitary old man, seeking with uncertain steps advancement along the path to becoming a true master of painting. [To achieve this,] I am willing to grow old. I am nearing my eighties, but I still have the same strong eyesight and brush power as I had in the prime of my life. If I could live to the age of one hundred, I would finally fulfill my aspiration to become entirely original. If you, too, should live until then, you will witness the truth of my words."

My guest left in anger.

This unlearned fellow shares this story for a laugh.

Translator's note: This postscript appears on the last page of *Katsushika's New Pattern Book*, which is full of Hokusai's annotations clarifying that he "abbreviated the drawings in order to reduce the block cutter's burden." In fact, most of Hokusai's drawings in this volume are extremely detailed. It is likely that Hokusai's publishers and block cutters were the ones who complained about his detailed drawings.

Translator's Note

1 Matsumoto (Tōsai) Moriyoshi (died 1870) was a copyist and calligrapher. In a letter to the publisher Kobayashi Shinbei, dated the nineteenth of the eleventh month (without a year), Hokusai asked for Moriyoshi to transcribe his preface to this volume. See Iijima Kyoshin, *Katsushika Hokusai den* (Biography of Katsushika Hokusai) (Tokyo: Kobayashi Bunshichi, 1892).

All about Painting in Color, Volume 1

Hachiemon the Unlettered[1] says:

With this small volume titled *All about Painting in Color*,
I have produced merely an easy guide to painting in
color, for the benefit of children who are keen on draw-
ing. Having worked independently and with an unflag-
ging spirit from the age of six until my eighty-eighth year,
I can hardly share, in these few square inches of paper,
an exhaustive account of the knowledge I have gained.
It is impossible for me to do more than merely indicate
that red and crimson are not the same, that blue and
green are different, and that shapes can be round,
square, long, or short. However, if additional chapters
were to follow, and volumes added, then I could eluci-
date properly the fury of the ocean, the sting of swift
currents, the stillness of lake water, and how strengths
and weaknesses differ for each and every living thing. I
could correct the errors that result in drawings of winged
birds that cannot soar or flowering plants that bear no
fruit—never mind that the effort would be akin to the
first step in a journey of a thousand miles. Maybe it is
presumptuous of me to set this book—my little gem
from the Crystal Mountains—on a desk beside those of
my colleagues who also dabble in this profession, but if,
upon comparison, there is not the slightest difference
in the way it shines, won't it serve as proof that I have
tottered along on the path of painting?

gu: A mixture of *gofun* with a pigment or *sumi*.

ayakari: The process of adding a small amount of another pigment to *gofun* to impart a watery appearance.

kime (the transparent top layer): The separated, upper layer of a liquid pigment.

kageguma (shadow gradation): The gradation from a low, recessed area to one that appears more prominent.

teriguma (highlight gradation): The gradation from a prominent area to a recessed area.

Note: *Enogu* (liquid pigments) should not be used as they are; an explanation follows below.

ON THE USE OF GLUE-BASED PAINTS

ōguma (broad gradation): Painting a thin layer of gradation, followed by a second, fine gradation in order to show greater coherence of form.

fukasu (a thin layer of gradation): Creating an extremely light gradation with color; it is important to realize this technique requires skill to execute.

nijimi (staining): Dripping a second pigment onto an area of still-wet pigment.

hasamu (suspending): Painting a design or pattern on top of a background layer of paint, then layering a pigment similar to the background color on top, so the design appears suspended between layers of color.

haru, *tsutsu-kake*, *okosu abiseru*: A detailed explanation is in the following pages.[2]

bunrokushō: A type of malachite green.

Shōindama rokushō:[3] A brand of malachite green.

awasegusa (blended grass): Dark Prussian blue mixed with *sekiō* (orpiment).[4]

seishitsu: Azure.

kusa no shiru (essence of grass):[5] Gamboge mixed with indigo wax.

byakuroku (pale green):[6] *Awasegusa* mixed with shell white.

cha-iro (brown): *Awasegusa* mixed with *bengara*.

ōdo (yellow ochre):[7] Orpiment mixed with vermilion or *bengara*.

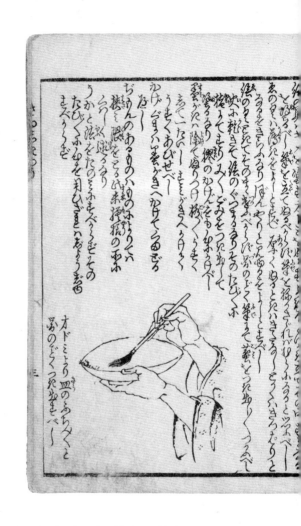

絵の具を[...]にてその[...]のぐるり[...]べし

オドミより皿のあらくと
ぶのどくつきせきをべし

ON THE USE OF GLUE-BASED PAINTS

ぶん綿青	松チ玉ろくせう	あゐろ	
岩緑青	べらうぐんに合へ	ちやゑ	雌黄 あをのぐ せゑう
肌色 しゆわん	庄吉丹又をるひ べんがら	きのぐ	猩々臙脂 あゐのぐ

shiō (yellow gamboge):[8] A partially transparent water-soluble pigment that ranges in hue from saffron to mustard.

sekiō or *kiō*: Orpiment.

kino-gu (yellow): Orpiment mixed with shell white.

bengara-niku: *Bengara* mixed with *nikushiki*.

shu: Vermilion.

Shōkichi tan: A brand of water-soluble *tan* (red lead oxide).

bengara (red iron oxide): A red pigment that can be mixed with orpiment.

shōenji (dark red):[9] A water-soluble red pigment.

nikushiki (beige): Vermilion or *tan* mixed with shell white.

bengara gofun (*kiō ni awaseru*): *Bengara* mixed with shell white that can also be combined with orpiment.

ōdono-gu (yellow): *Ōdo* mixed with shell white.

ōdo-niku (yellow beige): Orpiment mixed with shell white.

gofun: Shell white.

tōnotsuchi: White lead.

asagi (pale blue green): Indigo wax mixed with a small amount of shell white.

nezumi-iro (gray): Shell white mixed with a small amount of *sumi*.

kienji (pale purple).[10]

murasaki (purple): Prussian blue mixed with *kienji*.

usumura (lavender): *Kienji* mixed with shell white.

koi bero (dark Prussian blue): Also called *hanairo bero* (flower-colored Prussian blue).

sorairo bero: Pale Prussian blue.

iwa konjō: A darker shade of *gunjō*.

gunjō (light blue): Blue pigment obtained from azurite, with the finest particle size.

kira (mica): Hydrated or dried alum.

sumi (ink): *Kenbō*-colored[11] ink or ink made from oily soot.

taiheizumi or *tamazumi*:[12] Types of *sumi*.

hana konjō: Synthetic dark blue.

neri-airō: Kneaded indigo wax.

sumino-gu: *Sumi* mixed with a small amount of shell white.

mizu nikawa (*hirosuki*):[13] Animal glue dissolved in water.

senbon, *ichimanbon*: Types of animal glue.

uwasuki (*nami*): A type of animal glue (medium quality).[14]

arabiyakon: Gum arabic.

senjisuhō: Sappanwood dye.[15]

kezurizumi: Shaved *sumi*.

iroyoshi aigami: Paper dyed blue using dayflower.

murasaki mizu: Water-based purple dye.

murasaki gami: Paper dyed purple.

satsuma (*yanagi-nori*): A type of glue used for dyeing paper.

kinfun, *ginfun*, *suzufun*: Gold powder, silver powder, brass powder.

magaifun: Orpiment mixed with a small amount of indigo to create the illusion of metal powder.

haganefun: Copper powder.

* * *

Do not paint the upper layer with *kime* (the transparent top layer of a pigment), and do not paint the lower layer with *odomi* (liquid pigment). Stir adequately and paint with *nakazumi* (the blended mixture). Do not hold the brush upright. Instead, use the side of the brush, to avoid blotchiness.

Keep in mind that thin paint is best. Thick paint gets messy. A vivid effect should be avoided in every case. An indistinct effect is best.

Liquid pigment should not be used as is. It should be used only after any fine particles are removed with a brush. Steadily push the brush from the bottom of the dish toward the rim, as shown in the illustration (p. 44).

Pigment will coagulate as it dries. If this happens, repeatedly break it apart with your fingers and eliminate any fine particles; then you will be able to use the mixture to

paint. You should also pay attention to the quantity of animal glue.

When it comes to applying color, avoid painting over the outlines; instead, paint a thin wash of color toward the edges of the form.

Kageguma (shadow gradation) is applied toward the outlines of the form with *sumi*.

For some designs, such as kimono patterns, employ *hasamiguma* (a suspended wash). This is explained in greater detail in the section about patterns in this volume.

You should not rely solely on established practice. You will make no progress if you do not constantly think your own way through each illustration.

WATERWAYS

Mountains create ranges, and water forms waterways; both arise between the heaven and the earth.

Fascia encases muscle, and muscles surround fascia; combined, they create certain shapes.

Unexpectedly, people found grain while shaving wood, then named the pattern *mokume* (wood grain). The same process is true for gold and minerals.

If you understand these principles as you draw forms, how could you not master illustrating everything?

Therefore, you should take care not to lose the flow of the stream when you depict it splashing against rocks. When it encounters round stones, the pulse of the stream slows.

To depict water, apply a light wash of pale blue-green *kime* (the transparent top layer) over a light gradation of *sumi* (ink); add *kaeriguma* (inverted gradation)[16] in shell white for the areas where the water glows; introduce narrow lines of shell white between the contours of *sumi*.

For mountains, apply a wash of white *kime* on top of a light *sumi* gradation.

To add *tentai* (a mossy effect),[17] apply *harikomi* (an even coat)[18] of malachite green and then splash shell white from the bottom up.

Use pale-green pigment for the shadows of the waves.

For the lines that represent currents, apply shading in pale blue-green *kime*; apply additional shading in all the right places with darker pale blue-green *kime*.

Apply shell-white *kaeriguma* for whitecaps.

Add *kaeriguma* using shell white mixed with brown that

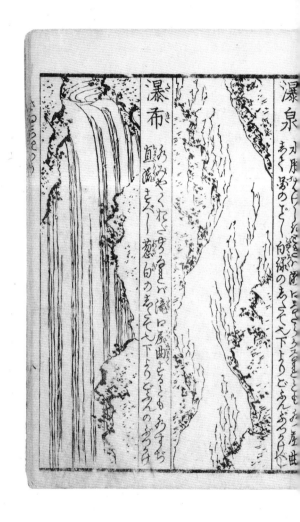

WATERWAYS AND WATERFALLS

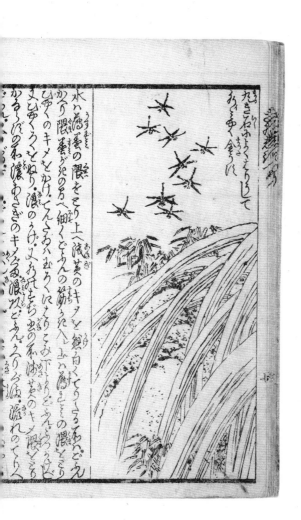

水に遠き薺の隈をとり上へ濃き薺のキメを細く白くてりくろ和らげぐゑ
かり隈薺が此の方へ細くどゝゑんの筋のうちへふかく濃きものゝ隈をとり
ひくくのキメをかけてんくろふみゝりにすりこみ下くろとどゝゑんくろうど
又ふかくろくとぬり浪のうげ又かけまち虫の和浪薺のキメ限をとり
かるくぶの和濃あさぎのキメる浪ひくどゝゑんるりう濃・濁れのてりく

丸きこねふよ〳〵うしておとき〳〵く金ろ〳〵

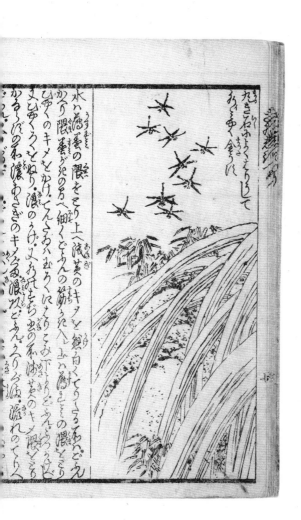

あさぎ

transitions into pure shell white for the highlights on the flowing water.

For fallen leaves and areas where dark-colored bamboo grass grows, paint using *kusa no shiru* (essence of grass) and add highlights using yellow gamboge.

WATERFALLS

When a waterfall flows from a rapid stream, the top of the waterfall appears gentle, but as the water falls, it surges from side to side as depicted in the illustration (p. 53). Use pale-green pigment and splash shell white from the bottom up.

When a waterfall flows from a calm stream, its top curves, but then it falls straight down. Use pale blue-green pigment and splash shell white from the bottom up.

WARM TINT

Waraiguma (warm tint) is used for flowers or women's faces; it naturally creates a warm feeling.

Shōenji (dark red) pigment usually should be boiled dry or dried in sunlight and stored until it is needed. This is a secret tip.

Boil *hanamotsuyaku*[19] and use alum to extract the color. If you do not remove the alum by boiling the pigment, the color will darken and the quality will be poor.

My method is to rub the *shōenji*[20] to separate the alum from the pigment. After this process is repeated a few times, the alum becomes fine like sand, and it is easy to brush away.

While shredding the *shōenji* into small pieces, still rubbing to remove the alum, add a little water to a small ceramic dish and put it over a flame. When the water is hot, add a piece of *shōenji* and squeeze out the color. Bring the water to a simmer and turn the dish repeatedly to prevent the pigment from burning; as the liquid boils down, reduce the flame. When there is just a small amount of liquid remaining, remove the dish from the heat and allow the liquid to dry completely while the dish is still warm.

Waraiguma can also mean applying a warm tint using pale-pink pigment, which is made by mixing diluted shell white and *shōenji*, and then layering this mixture over a diluted shell-white ground.

When you apply a wash with a water-based pigment, often the pigment appears uneven. This does not look good. You should add shell-white *kime* (the transparent top layer) every time you use wet pigment to apply a wash.

Do not hold the brush upright when applying gradation; doing so makes it more difficult for yourself. Except for *kotsugaki* (contouring), do not raise the brush. The brush never lies, so please do not do what you should not.

SUNFLOWERS

Treat the leaves in a similar fashion to the tobacco leaf.

Apply *fushiguma* (a fine shading) using a light wash of *kusa no shiru* (essence of grass) to the stems.

Paint the thick stems using pale green; add lines of whitish pale green as in the illustration (p. 59) and apply *fushiguma* in *kusa no shiru* on top; add dots of *sumi* (ink); paint the prickles using an even wash of malachite green.

Paint each flower petal with yellow pigment mixed with shell white; apply a wash of yellow gamboge from the base to the tip; for the front petals, apply *usuguma* (a light wash) of vermilion *kime* (the transparent top layer) around the base and draw the central fiber of the petals using yellow pigment mixed with shell white.

Paint the inside of the sepals pale green; add dots using shell white and apply a wash of yellow gamboge on top. Alternate shades of pale green as if drawing a crescent moon, and then add dots in shell white.

Paint [the edge of the disc florets at the center of the sunflower] using a thick mixture of *bengara* (red iron oxide) and *sumi*, then apply *shōenji* (dark red) *usuguma* on top.

For the back side of the flower, apply a fainter color than is used on the front.

TOBACCO PLANTS

Paint the sepals pale green; the stem should be *hariguma* (evenly painted) in white green and shaded by using a top coat of *kusa no shiru* (essence of grass).

Fill in the flowers using *nikushiki* (beige); apply *waraiguma* (warm tint) with *shōenji* (dark red) *kime* (the transparent top layer) around the edges; apply *kaeriguma* (inverted gradation) in shell white.

Draw five thin pistils using shell white.

Use malachite green for the center of the flowers.

Paint the petals using *taisha* (brown pigment), then coat evenly with a mixture of yellow pigment and shell white.

Paint the front leaves with a mixture of orpiment and *awasegusa* (blended grass); apply *sōguma* (general shading) using a light wash of *kusa no shiru*; add *wariguma*

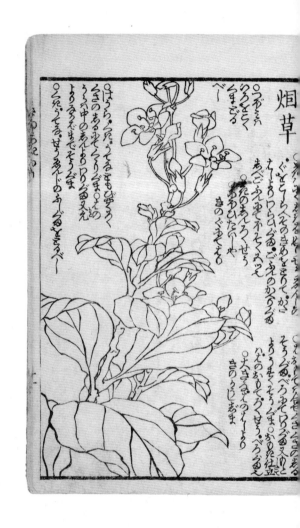

烟草

べ―

○うぐらく
ろくとく
ぐまぐる

はうら・○だ・でるまもびゃく
ぐきのあるぞくゃりぐまO○
うらの中のあれよりとりぐるえ
よろぐくるぢまでそうぐまえ

べとうらくその昔めをとりてすがに
そーより〇らひぐまごぶのかへぐる
あごぶのあしろくぞくみっえ
だのあしろくせう
あめひたいーや
きのぐきえぞる

○二だ・でる・せうあれどのふーぐまとそうぐべー

そうぐめ・べろめてばぐるえのこと
ようぞくそうぐまえ○あめのた立
ひえのおゃぐろくせうーより・べろぐるえ
○大さるぐれのえーより
きのうろじまま

TOBACCO PLANTS AND SUNFLOWERS

58

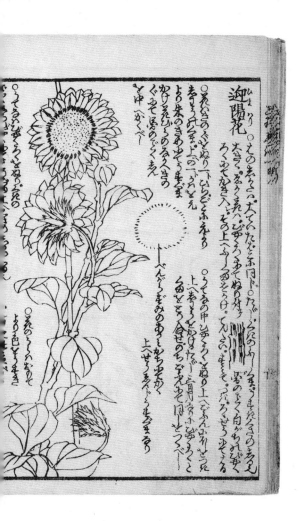

迎陽花

ひまはり

○その花の心大きく丸くして正面向く

○これなきのぶにぬり「ひらどふる也」

○うてなのぶぎりのぶとぬりて先の

○花のしんのあかくて

と中へかくべし

○うてなの中じろくあつく

べんぐらぎみのあつきもちゆきかく

(partially colored gradation) in Prussian blue; apply *sō-guma* from the base to the tip in a thin coat of Prussian blue.

To show the thickness of large leaves, paint the front side using malachite green with a Prussian blue gradation. Apply a checkered pattern to the edge of the large leaf form using yellow pigment.

Paint the back sides of leaves, stems, and sepals pale green; apply *kukuriguma* (outline shading) using *kusa no shiru*.

Apply *wariguma* to the backs of the leaves, beginning in the center and moving outward; apply *sōguma* from the base to the middle of the leaf.

Apply *shōenji fushiguma* (a fine shading) to the stems and sepals.

HOW TO COLOR BIRDS

Around the eyes, the sides of the beak, the nostrils, and the neck, between the neck and the back and the small feathers and the double-feathered wings, on the tip of the rear wing feathers and the base of the flight feathers, from the belly to the rump and the tail, apply a shell-white gradation and feather lines.

Use dark *sumi* (ink) for the pupils, nape, small feathers, flight feathers, crown, under the eyes, and on the dark circles above the cheeks. Apply *damiguma* (a covering wash) of light *sumi* on top.

Apply Prussian blue *fukashiguma* (a thin layer of gradation) over the black feathers.

Other details will be explained elsewhere.

WHITE PHOENIXES [21]

Apply yellow pigment to the beak.

Use a *shōenji* (dark red) *kageguma* (shadow gradation) on the comb and cheeks, and *nikushiki* (beige) with a shell-white speckled pattern on top for the body.

Mix *ayakari* (watery) white pigment with shell white for the forehead, *kezuno* (hairy horns), and the tiny wings on the collar and shoulders.

Mix *ayakari* pale blue-green pigment with shell white for the small rear wing feathers.

Mix *ayakari* yellow pigment with shell white for the large rear wing feathers.

Mix *ayakari* gray pigment with shell white for the flight feathers.

Use white pigment when painting the *sasao* (tail feathers that look like bamboo grass [p. 65, bottom left]).

For the beak, the mandible, and from the belly to the legs, paint using *harikomi* (an even coat) of *ayakari nikushiki* pigment mixed with shell white, and introduce narrow lines of shell white between the *sumi* (ink) feather lines.

Use *nikushiki* for legs—details later.

For the back feathers, add gradation using shell white.

Mix *ayakari nikushiki* pigment with shell white for the sword-shaped feathers.

Paint the *soeo* (secondary tail feathers) using *ayakari* pale yellow green mixed with shell white.

For the two *nakio* (longer tails), use *ayakari* yellow pigment mixed with shell white, and paint thin shell-white lines next to the *sumi* feather line contour.

For the circles on the tail feathers add a gold-colored gradation, which is made by mixing yellow pigment and Prussian blue. As shown in the illustration (p. 64, center),

paint the inside of the circle using Prussian blue, without overlapping the contour lines. Add yellow pigment to the inside of the circle.

Use shell white for the areas of small feathers and sword-shaped feathers, and add a very thin shell-white feather line.

Evenly paint between the outlines of the legs using deep shell white.

Here is an example of rear wing feathers (p. 64, top left).

Use yellow pigment for the eyes. Apply a dark *shōenji* gradation to the inner corner of the eyes. Paint a *harikomi* of Prussian blue within the iris. Use *shōenji* for the outer corner of the eyes.

Add dots of shell white amid the secondary tail feathers.

Treat the two longer tails in a similar fashion, as seen in the illustration (pp. 64–65).

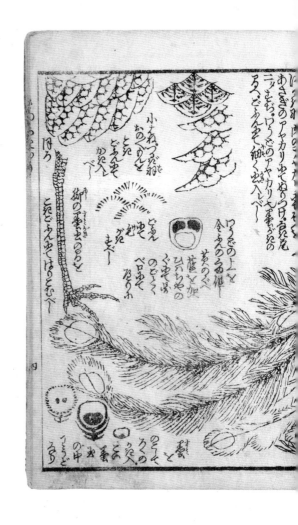

WHITE PHOENIXES

64

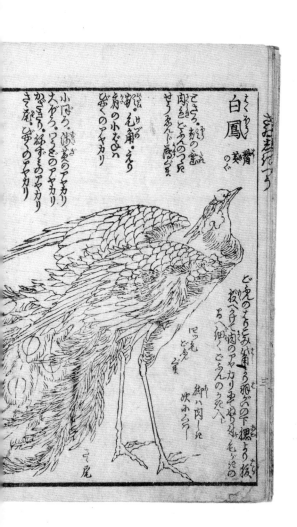

ABOUT DIFFERENT COLORS ON ONE SIDE OF A BIRD'S FEATHERS

Paint bird feathers in halves using gray; apply a *sumi* (ink) gradation from the edge of the feather to the center, and then apply shell-white *kaeriguma* (inverted gradation) from the base of the feather to the center.

For the other side, paint using *ayakari* (watery) gray; draw feather lines with shell white; apply a shell-white gradation beginning at the base.

ROCKFISH [22]

Paint the overall form with yellow ochre, then apply a *taisha* (brown pigment) gradation following the line of the spine.

Apply a *taisha* gradation from the base to the tip of the fins and the tail.

For the chin and the fins on the belly, apply *kaeriguma* (inverted gradation) using *ayakari* (watery) yellow ochre.

Paint a thin line of shell white around the eyes.

Apply *harikomi* (an even coat) of Prussian blue for the irises.

Apply a *shōenji* (dark red) gradation to the nostril, as illustrated (p. 69, right).

Apply a *shōenji* gradation from the neck to the spine.

For the forehead and the cheek, use a *shōenji* gradation.

Use *shōenji* on the tip of the fins, drawing a thin line to the edge of the fins.

ABALONES

For the edge of the shell muscle, apply a pale-green gradation using *kime* (the transparent top layer).

Paint the overall form using yellow ochre and apply a downward gradation, beginning at the top, using *awase-gusa* (blended grass).

Apply layers of *hasamiguma* (suspended wash) using *taisha* (brown pigment) on top of dots painted with yellow ochre and *taisha* on the side of the muscle, as in the illustration (pp. 68–69).

For the seaweed, add malachite green between the *sumi* (ink) outlines.

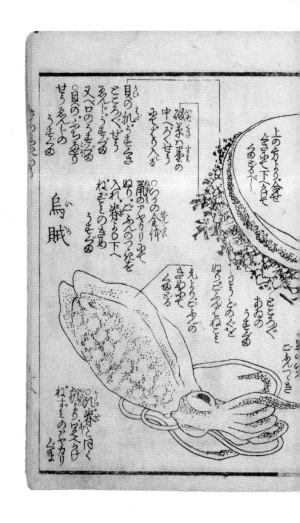

烏賊

SQUID, ABALONES, AND ROCKFISH

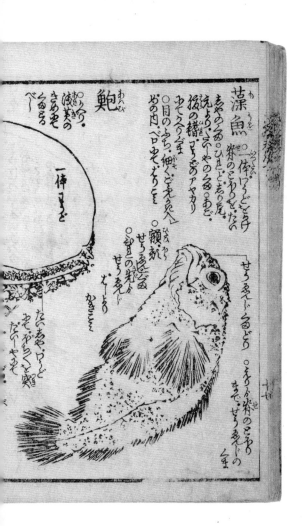

藻魚 <ruby>あ<rt></rt></ruby><ruby>を<rt></rt></ruby><ruby>うを<rt></rt></ruby>

鮑 <ruby>あ<rt></rt></ruby><ruby>わび<rt></rt></ruby>

一倬ほど

Apply a light gradation of *shōenji* (dark red) or Prussian blue to the small seaweed fronds on the shell, and apply a light gradation of *shōenji* to the edge of the shell.

Add *usuguma* (a light wash) of indigo along the edge of the muscle as necessary.

Paint the surface of the shell yellow mixed with shell white and add shell white in places [to create the texture of the shell].

SQUID

Paint the overall form using *ayakari* (watery) gray, add small dots in shell white, and top with *usuguma* (a light wash) of gray *kime* (the transparent top layer).

Add small, shell-white dots to the suckers.

Apply a gradation of shell-white *kime* to the base of the mantle.

The head, forehead, and back are all the same: apply a downward gradation of gray *kime* toward the tentacles.

ABOUT THE COLOR BLACK

Since the old days, only *sumi* (ink) has been used for the color black.

When painting black clothes, I have never seen someone draw several lines and fill in their outline to create [a black] gradation.

To understand coloring is to understand the different types of black—there is a difference between old and new, shiny and matte. There is also a difference between black seen in the sun or in the shade, on a square surface or a round one.

Paint "new" black using a mixture of *sumi* and indigo wax; for "old" black, add *bengara* (red iron oxide); for matte black, add a little shell white.

For clothes, add an outline using dark *sumi*, and then apply gradation in mid-tone *sumi*.

To paint housewares, do not draw outlines, just mix three different shades of black, and the edge will appear naturally. Apply a coat of animal glue for glossy wares. Apply *orandaguma* (Dutch gradation)[23] for round wares, as illustrated on the following page (p. 73).

くらき所ともまた

ろく果當りたる

をそくまはる少を

ふより・かげぶるとて

をれるをとそ隔く

をかげぶるとて

黒うろ・かげ・もぎ

あるぎれがさおれ

てい・ねうがく

○くにてとうげ

○あうでとうをう

うけゞくてうぶを

○地ぬりの色うり

濃らうすて・るのどり

泥絵の具そて摸様をかきそ

せん限どうし儘のぐを

摺めふうすてえのさるふるぐるどきを挟むとふるり

Use *sumi* for the flat surfaces of square objects.

Use a mixture of *bengara* and *sumi* for areas that reflect light.

Use a mixture of *sumi* and shell white for shadows.

For round objects, apply *teriguma* (highlight gradation) in shell-white gray. Add black paint mixed with shell white, then add gradation, as seen in the illustration (p. 73, top left).

For a box with many corners, paint separately using three different blacks as in the illustration (p.73, right), and apply gradation inward from the corners.

As these colors are all painted with *sumi*, I added dots to indicate the areas of gradation.

These objects (p. 73) appear to have a British-style [24] *keshiguma* (matte gradation) because this is a printed book.

For the coloring, please apply the gradation as explained in the following sentence.

Apply gradation, then add animal glue, to create a shiny effect.

Teriguma indicates the gradation used in an area that reflects light because it is higher than the rest.

Kageguma (shadow gradation) indicates the gradation used in an area that is shaded to make it appear recessed.

Without shadows and highlights, it is hard to call it "coloring."

This trellis (p. 72, center) is an example of using *kageguma* for the shadowed areas and *teriguma* for the highlighted areas.

KIMONO PATTERNS

Here I will explain how to paint striped textiles.

The usual practice is to first apply a wash of color, then paint a striped pattern in a color mixed with shell white. However, if the first layer of wash cannot be seen beneath the pattern, then this approach is useless. Another layer of the wash should be applied on top.

The parts [of the plain kimono] (p. 77, top) that are printed using solid areas of *sumi* (ink) are the parts in *kage* (shadow). The unprinted areas represent reflected light, so paint them a whitish color.

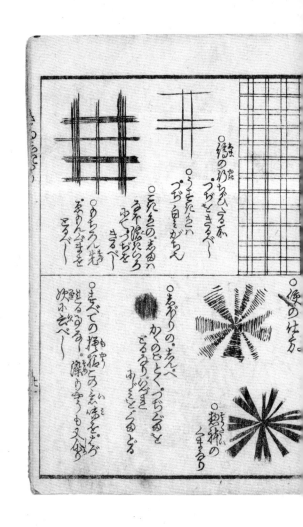

○縫の羽ちび弓本
づゞをきるべ〜

○うてきたらに
づゞ白きがちん

○えきの・あ白ん
み年漲れふろ
ふゞつゞを
きるべ〜

○もちろん先
ゑりんぐまを
とるべ〜

○縫の仕方。

○あをりの・みんべ
かくのとく゛づゞぐ爲と
とるなり。ぢまと
ぬゞしとぐ爲とる

○繋繊の
みくるる

○まゞての揮猾との
とるなり。
くゑ先をぢゞ
染め爲ふも又ぐりゑ

TIE-DYED TEXTILES AND KIMONO PATTERNS

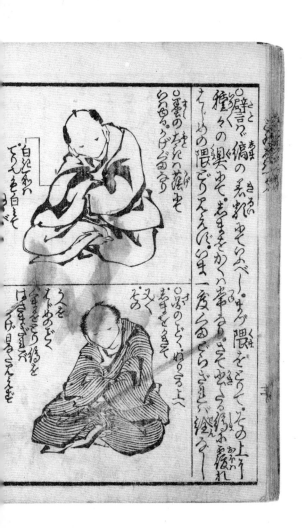

As in the illustration [of the striped kimono] (p. 77, bottom), paint lines over an applied wash of color, then apply a top coat of the same wash. If you do not apply layers of wash above and below the striped lines, you cannot create the effect of shadow and highlight.

Where stripes intersect, draw crosses.

When using light colors, the crosses tend to appear whitish.

Use even darker colors when drawing the crosses for dark stripes.

Of course, you should apply *emonguma* (general shading for cloth) first.

TIE-DYED TEXTILES

Every line is shaded.

For the center of the pattern, apply *tsujiguma* (central gradation) as in the illustration (p. 76, bottom). Apply *nijimi* (staining) and blur the edges.

This technique is used for all patterns, including all other dyed patterns. I will expound on this technique on the pages that follow.

For the color red and for light yellowish green, apply yellow *nijimi* (staining) on top.

For indigo, dark blue, and sky blue, you should add a top coat of *nijimi* using *ayakari* (watery) pale blue green.

For purple *nijimi*, light purple should be applied on top.

Nijimi using *sumi* (ink) mixed with pale green is used on top of dark gray.

For black, apply gray *nijimi* on top.

There is a specific color *nijimi* that should be applied for each color of dyed textile.

Without knowing the rule, people often paint checkered patterns and other patterns with shell white. This should be changed.

Apply a gradation in *shōenji* (dark red) over a base wash of vermilion.

For some patterns, apply a gradation in vermilion or *shōenji* over the ground using Shōkichi-brand *tan* (red lead oxide).

For crane patterns, paint yellow on top of a mixture of yellow and *nikushiki* (beige).

For flower patterns on a dark blue background, paint the flowers using pale green Prussian blue, followed by a thin top coat of *fukashiguma* (a thin layer of gradation) in dark Prussian blue. When using pale green for the flower patterns, apply a light wash of shell white to the inside of the flowers.

For bamboo leaf patterns where *sumi* is applied to the ground color, paint the outlines using shell-white gray, and apply *usuguma* (a light wash) of shell white within the outline.

METHODS FOR MANUFACTURING PIGMENTS

White lead: Since white lead contains lye, it turns brown over time. This is how to remove the lye.

Wrap the white lead in a piece of paper and insert it into a quarter block of tofu [25] as in the illustration (p. 83, bottom right). Cover the tofu with water and boil well. When the tofu turns yellow, remove it from the heat. Take the white lead out of the tofu without tearing the paper. Place a second piece of paper on a bed of ashes, unwrap the white lead, and place it on the prepared paper and ash to draw out the water, then dry it in the sun.

The same process is used to prepare *neri-airō* (kneaded indigo wax).

PRODUCING KNEADED INDIGO WAX

2 *kanme*[26] (7.5 kg) indigo scrapings
1 *shō*[27] and 5 *gō*[28] (approximately 2.7 L) lime
400 *mon*[29] (approximately 1.5 kg) Maeiwa-brand *tankiri* (rice candy)

I have illustrated the process of making indigo wax (p. 83).

Add lime and candy to a *kama* (large pot).
Mix using a *sasara* (whisk).
Put the basket of scraped indigo into the pot and put it on the heat.
The indigo foam will bubble up.
Scoop out the foam and put it into a bucket.
Strain the foam through oiled paper into a basin; the foam will disperse immediately.
Allow the resulting indigo water to evaporate.
Place ash or sand underneath the oiled paper while the indigo water evaporates.

▲油繪ハ〼の色を油の墨付をひ

○ゑの油を合○弘をけづりて入地中に埋め七十日ほどあてとき出して用ゆ○これ阿蘭陀の傳来にて今紙烟草入れもあまた

○みづの油○称らうく筆をゑがくにもちゆ○後ゑのぐにまぜ○且朱土の画法にならひ泥画○泥画のふせいの外出るゆるさまざ○禽獣草木虫魚をゑがくの法

▲油小和するの繪のぐだ水泥をさえる同く隈どる△別の法

○唐の玉○せるき○べろ○きりう○きゑん○ぎんがら○たん○金あんつアラビヤコンゑて○用也

○朱○もゑ墨○▲入用乃○せう〼し○△金ゑ

○にる木○こう紙○漆ぬるぞ○とりこみ刷毛大中小○ねり鉢○ぬり盆○焼明礬と入るゝ

PRODUCING KNEADED INDIGO WAX

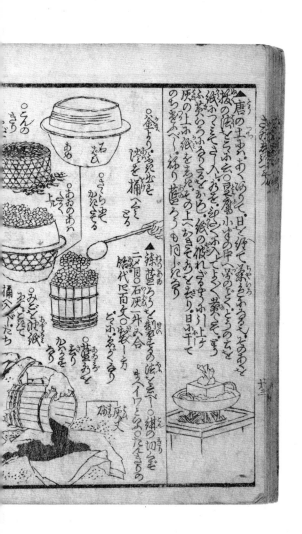

△唐の土あぶらにて、日を経て漆をふるこ、そのあと　按の底にくぼみとぼふ玉○定蜜小す玉の中へ玉のどぶ、とうのふる　紙かつてそこへ入、あぶ玉にふ玉よくよく熱をそへ、もう　ふみふろふろそのふる玉をとり、紙の破れさるぶろふり上げ　灰の土か紙をとめたるその上へふきそれをぶり、日に干て　のち玉をふべし、ねぶり墨うも同じ玉う

○釜しろりふろがまを　沙を桶へ玉る

○石ぐちに　あぶ

○せくら虫　かたにさる

○あをのあく　かたにさる

○えんの　きり

△沐莖ろろを割　ねぶ玉を　二匁○石灰一升よ　始代に百文○玉をり一方　こふるぐ玉を

沐莖ろろを割、のちその沈と玉う○緋の切玉を　まイワとふろのにもふ玉をを

硲灰ふ

○みどふ沖紙　桶へ入ぶり、玉たち

MAKING OIL FOR OIL-BASED PIGMENTS

1 *gō* (approximately 180 mL) perilla oil

Grind lead shot and bury it in the ground for about seventy days, then take it out and collect the oil from the surrounding soil. Store it in a paper tobacco case until needed.

Mitsuda oil [30] is so sticky that it is difficult to use with a brush, and the pigment turns yellow over time. This method is not like the Dutch way; only use this material for *doro-e* [31] paintings [no other style].

[I will explain] the technique used to paint all kinds of birds, animals, plants, insects, and fish so they look alive [in the following volumes].

PIGMENTS THAT WORK WELL WHEN MIXED WITH OIL

The way to dissolve the pigments [below], the method of achieving gradation, and the technique of dividing the pigments into three parts are always the same.

tōnotsuchi (white lead)
seishitsu (azure)
bero (Prussian blue)

kiō (orpiment)
kienji (pale purple)
bengara (red iron oxide)
tan (lead oxide)
shu (vermilion)
yuen zumi (oily soot ink)
shōenji (dark red)

Gold powder should be dissolved with *arabiyakon* (gum arabic).[32]

ESSENTIAL TOOLS AND IMPLEMENTS

Wooden spatula
Filter paper
Large, medium, and small brushes from a lacquer shop
A board or tray to use as a pallet
Calcined alum (added to pigments for painting on glass)

ILLUSTRATED INSTRUCTIONS FOR MAKING OIL

Shave seven 3-*monme*[33] (11.25 g) lead shots. (Please measure the correct amount.)
Mix the shredded lead in a jar with 1 *gō* (approximately 180 mL) of perilla oil.
Bury it in the ground for about seventy days.

右の繪の具晴天ホ一日干上をし然るけれが油浮て黄金

出るより

○油ゑのくば行そも庫の去をおゝゞ入せざれば乾方あそ

○硝子へ裏より彩色とをするゆあり表より表再して

○裏より隈と先くるべし

○夫より地塗をし撰揉ハ竹の揚枝そかくそのく

をば繪の具ふをさゞびて外の繪のぐを塗ちべし

○惣ての繪れぐの中（焼明礬を入々煮るゝれがづくゝゐゑ

一度ふ色の彩

○玉盤も裏より彩ゐくの勿繪すり

色きゝ其是もづくゝと流るゝのゝゝ残うその繪の具

ILLUSTRATED INSTRUCTIONS FOR MAKING OIL

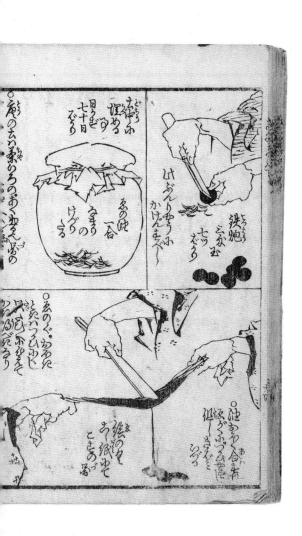

○彫のゑい兼ろのあく出さん者の

六十分升
埋める
日ほど七十
なり

ゑの池一合
つまりの
けづる

けぶりさうふ
かけんまく〜

鉄炮
二分玉七つ
だうり

○ゑのぐおめた
とくつうひゆじ
ちしぶあてそ
るめだうり

絵の見
う紙やそ
こちあう者

○油
さうわく令升
派がうふづる立
似くきうなど
ひだうう

White lead may contain brownish lye. As in the previous illustration (p. 83, bottom right), insert the lead into a block of tofu and boil before using.

The more oil you add, the easier it is to use the pigment with a brush, but the color will yellow.

Strain pigment using filter paper and a spatula (p. 87, bottom). It is difficult to strain a large quantity of pigment. Divide it into smaller amounts and allow it to cool before straining.

Dry the pigments in the sun for a day (as previously mentioned), otherwise they will turn yellow as the oils rise to the surface.

For oil-based pigments, add white lead gradually to prevent the pigment from drying too quickly.

When painting glass, color the back side. First, outline the design on the front and then apply the colored gradation on the back. Then, paint the *jinuri* (undercoating) and add patterns using a bamboo toothpick [on the front]. After that, add pigments based on the color of the pattern on top.

Always add calcined alum to the pigments used for painting glass, otherwise they will be too runny.

When you paint glass bowls, of course you paint on the inside of the bowl. If you are using many colors at once, you must make sure the pigments are not runny, so add grated calcined alum to each pigment. Once you add calcined alum and mix it well, the pigment will not run or bleed but will set quickly and perfectly.

Since glassware is naturally shiny, it is not a problem to dilute a raw pigment with perilla oil.

By the way, European and Japanese techniques of coloring are completely different. In China and Japan, which are both on the continent of Asia, people know that drawing pictures is akin to creating patterns. Asian artists will not add materials like gold to thicken their pigments [and create texture through raised layers of paint]. Without grasping these basic concepts, how can you draw?

The end of *All about Painting in Color*.[34]

ON ALL ABOUT PAINTING IN COLOR, VOLUME 1

This volume of *All about Painting in Color*, which has just been published, includes [instructions for painting] mountains, rivers, grasses, trees, birds, animals, insects, and fish. It also gives detailed instructions for depicting patterns on fabric, human skin tone, implements like

armor and harnesses, the elegance of the wind and rain, and the gradations of the shadows cast by the moon.

As you progress through the book, you will learn how to depict a scene behind a bamboo screen, the patterns showing through a lightweight kimono, how to dissolve pigments, and different ways of creating gradations. This is an easy-to-follow book, suitable even for children who love art.

The book is in a smaller format to make it affordable. As additional volumes are published, one after another, I, Hokusai, will tell you what I have learned from living for more than eighty years. I wish only that, when I become ninety years old, I will change my artistic style, and after one hundred, I will entirely reform my way of painting. I pray that long-lived men bear witness that my words are not wrong.

Translator's Notes

1 This means "a simple doodler." Hokusai often used *muhitsu* (unlettered) in his signature, expressing his self-deprecation. The ukiyo-e scholar Inoue Kazuo (1914–1939) mentioned that this sort of self-deprecation is indicative of Hokusai's eccentricity.

2 Though explanations for these terms are not explained in the published volumes, they were defined in the manuscript *Saishikitsū shūran*, now held in the collection of The Museum of Fine Arts, Boston.

3 According to Josiah Conder, it is "a powder of emerald-green color, produced from copper, by a process in which several different depths of the color are precipitated. The best and brightest, which is at the same time the coarsest and most difficult to use, is called *iwa-rokusho*. A second quality, finer in grain and somewhat paler in hue, is called *ao-ni-ban* [the second blue]. A third quality is called *shiro-ni-ban*, and the palest quality, of a milky emerald green, is called by the abbreviated name *byaku-roku* [white rokushō]. All these qualities have their special uses in painting. Common verdigris, made by pickling copper, is sometimes used as a substitute, for it is difficult now to obtain the pigments of the purity and intensity employed by the old painters. Josiah Conder, *Paintings and Studies by Kawanabé Kyōsai* (Tokyo: Maruzen Kabushiki Kaisha, 1911), p. 21.

4 Orpiment is a yellow arsenic sulfide mineral.

5 Conder writes, "Ai and shiwo, making a transparent green, called in painting *kusa-no-shiru* [essence of grass]." Conder, *Paintings and Studies*, p. 23.

6 According to Conder, "*Biaku-roku*, *shiwo*, and *gofun*, mak[e] a more delicate and opaque green, resembling the leaf tints of early spring." Conder, *Paintings and Studies*, p. 23.

7 Conder, *Paintings and Studies*, p. 21.

8 Conder, *Paintings and Studies*, p. 21.

9 In the seventh century, *shōenji* made of lac dye was brought to Japan from China. However, according to *Tansei shinan* (Tokyo: Tōkyō Bijutsu Gakkō Kōyūkai, 1926) pp. 17–18, *murasakigusa* (plant-based red) was often used in place of *shōenji*. Conder also mentions *shōenji* in his book: "A Chinese vegetable dye for color resembling rose-madder. It is collected in wads of cotton or wool, and to prepare the color for the painter's use, a piece of the wad is torn off, placed in a saucer, and soaked in water. This color is generally referred to by the abbreviated name of *enji*. It is a transparent color, used for glazing over other colors, or for mixing with whiting to form a rose tint." Conder, *Paintings and Studies*, pp. 21–22.

10 No definition appears in the volume, however *kienji* is created by mixing sappanwood dye with shell-white pigment.

11 *Kenbōiro* is a brownish black invented by the Kyoto dyer Yoshioka Kenbō in the early seventeenth century. Yoshioka Sachio, *Nihon no iro jiten* (Kyoto: Shikōsha, 2000), pp. 248–249.

12 *Sumi* is made from the soot of burnt pine roots.

13 Also called *sukinikawa*, *nikawa* (animal glues) are dissolved in water before use.

14 Although further verification is required, in this context the term

likely refers to a type of animal glue (adhesive dissolved in water) used to prevent blurring.

15 Details about sappanwood dye are given in the second volume under the title A Meddlesome Old Man's Extra Notes: Boiling Sappanwood Dye.

16 The application of colored gradation surrounding a subject in order to provide definition.

17 A technical term for adding dots that indicate moss or small plants on rocks or branches in landscape paintings.

18 Painting in such a way that a penumbra of the under-color remains visible. This explanation comes from Hokusai's commentary in *Saishikitsū shūran*, now held at The Museum of Fine Arts, Boston.

19 A material extracted from lac insects that is used to create *shōenji* red.

20 Hokusai might have used *wata-enji* (a cotton disk) to rub the pigment.

21 In Japan, the *hakuhō* (white phoenix) is an imaginary bird that is a sign of auspiciousness. Hokusai produced an eight-panel folding screen depicting a phoenix in 1835 and, later, a huge ceiling painting of a phoenix in Obuse.

22 The *mouo* (rockfish) lives along the coast, where seaweed grows.

23 A gradation that gradually gets brighter toward the center.

24 The text says *Igirisu-ban*, literally "British version," however the meaning in this context is not entirely clear.

25 A standard block of tofu is 300–400 grams.

26 A unit of weight, in which 1 *kan* is equal to 3.75 kilograms.

27 A unit of volume equal to approximately 1.8 liters.

28 A unit of volume equal to approximately 180 milliliters.

29 A unit of weight, in which 1 *mon* is equal to 3.75 grams.

30 A litharge oil mixed with perilla oil and *mitsuda-sō* (lead monoxide) and boiled.

31 *Doro-e*, a style of painting introduced at the end of the Edo period, used opaque pigments mixed with shell white. Most of time, this style was used to paint theater signboards or *ema* (votive pictures) in shrines.

32 A binder for pigment.

33 A unit of measure in which 1 *monme* equals 3.75 grams.

34 This note appears at the end of the volume. In the original Japanese, the title is given as *Gari saishikitsū*, a variant of the official title of the volume, *Ehon saishikitsū*.

All about Painting in Color, Volume 2

The first volume of *All about Painting in Color* was a success, so a second volume has been prepared. With his innate skill, the old man—formerly known as Hokusai—first pronounced himself a painter in the year of the monkey, when the name of the era changed to Meiwa (1764). From that tender age, he has devoted himself, heart and soul, year after year, to this vocation, and now he is eighty-eight.[1] He has attained a wondrous, godlike skill at painting and truly merits the name *Manji ga shinsen*: Manji, the Sacred Immortal of Painting. His numerous pupils flourish throughout every province; those who flock to study with him are like ants swarming to honey. Even those who cannot be in Hokusai's proximity long to learn his style of painting, like infants yearning for their mothers. To help those who enjoy the way of painting, he created numerous *manga* volumes.[2] Now he has revealed his "top secrets" of coloring. From the first time you open this book, you will attain prodigious skill; after two or three perusals, you will fathom painting's deepest meaning—it will be as though Hokusai himself is leading you by the hand. This volume truly is the key to the art of painting, so open it and become enlightened to hidden truths.

Written playfully by Hōkaishi,[3] 1847

Although I have written about this before, I am providing instructions for the use of pigments again, for those who have not read the first volume.

I will share a method for easily creating the effect of water-soluble pigment using an earth pigment.

Any kind of colorant can be mixed with *gu* (shell white). Use *kime* (the transparent top layer) of *-gu* pigment as a water-soluble pigment. When you use this, there are no areas of uneven color. Also, it will not leave overlapping brushstrokes when applied as *jiguma* (a foundation wash).

For *fukusa* paper,[4] apply *jiguma* in order to spread the pigment evenly. This makes it easier to spread the pigment in any direction, which is especially beautiful. The results will not look like water-based coloring.

Any time shell white is used in a mixture, the mixture is called *-gu*.

taisha (brown pigment): [5] Each pigment has different qualities; add *bengara* (red iron oxide) mixed with *sumi* (ink) to adjust the color. You must consider the exact color and vividness you desire, since the color is determined by the pigment you use.

awasegusa (blended grass): A mixture of orpiment and indigo wax.

ōdo (yellow ochre): Orpiment combined with vermilion, *tan* (red lead oxide), or *bengara*.

kime (the transparent top layer): The transparent upper layer of a liquid pigment.

bero (Prussian blue): A range of Prussian blues are available, including *koi bero* (dark Prussian blue), *sorairo bero* (pale Prussian blue), and *asagi bero* (pale blue-green Prussian blue).

asagi (pale blue green): Indigo wax mixed with shell white.

kino-gu (yellow): Orpiment mixed with shell white.

nezumi-iro (gray): Shell white mixed with *sumi*. Strengthen or weaken the color depending on the pigment you use.

sumino-gu: *Sumi* mixed with a small amount of shell white.

byakuroku (pale green): Each pigment has a different quality, therefore combine with other pigments, such as orpiment, indigo wax, or shell white [to adjust the color].

Add or reduce depending on the quality of the pigment.

nikushiki (beige): Vermilion mixed with shell white.

tan-niku: *Tan* mixed with shell white.

bengara-niku: *Bengara* mixed with a small amount of shell white or orpiment.

enjino-gu: *Shōenji* (dark red) mixed with shell white. Add or reduce the red depending on the colors of the pigment.

Note: Pigments more yellow than animal glues are *tama-rokushō* (malachite green) and *kienji*[6] (pale purple).

usumura (lavender): Shell white mixed with *kienji*.

murasaki (purple): *Sorairo bero* mixed with *kienji*.

ayakari: The act of adding a small amount of any pigment to shell white in order to give that color a watery appearance.

kusa no shiru (essence of grass): Gamboge mixed with indigo wax.

usu-zumi (light *sumi*): Made from the clear top layer of *sumino-gu*.

Note: As it is not easy to create *shōenji*, Prussian blue, *gofun* (shell white), and *tamarokushō*, the detailed process for each is explained later in this volume.

beni (crimson): A coat of *nikushiki* (specifically vermilion mixed with shell white or *bengara*), followed by a gradation of *shōenji*.

aka (red): A coat of vermilion topped with lines of orange pigment, followed by a gradation of vermilion and *shōenji*.

byaku (white): A coat of *byakuroku* topped with shell-white lines and a shell-white gradation.

ki (yellow): An even coat of *kino-gu*, topped with shell-white lines and a shell-white gradation.

HOW TO COLOR PLANTS

Plants and trees are not just one shade of green. The stems of flowers and fruits that die in the summer are soft, and their leaves are thin. Use light green for these plants.

Use deep green for plants with flowers and fruits that die in the autumn. Their stems are thin and rigid, and their leaves are deep green in color, so apply *fushiguma* (a fine

shading) of *shōenji* (dark red). Plants that grow thick and sturdy have dark leaves. Grasses retain a deep color throughout the four seasons.

Early spring is the same as winter; late autumn is closer to summer.

For plants with thick joints, apply *fushiguma* using a strong *shōenji*, made by dissolving dry *shōenji* pigment.[7]

Purple plants absorb iron from the soil. These plants have dark, deep green leaves, and the centers of leaves are purple too.

Plants and trees grow differently. Plants with branches that look like deer antlers have leaves with cross-shaped veins.

The base of the petal is the core. Petals have veins. The core cannot be seen when flowers have many petals.

PEONIES

I'll explain the correct order for painting peonies.

For red flowers, paint the petals using *nikushiki* (beige) and paint the flower's veins using shell white. Apply a

light wash around the base in *shōenji* (dark red) *kime* (the transparent top layer), so the back-lined flower vein in shell white looks natural. This technique is called *okoshiguma* (elevated wash).

For peony leaves, paint the veins with malachite green, apply *wariguma* (partially colored gradation) and *sōguma* (general shading) in pale Prussian blue.

Draw the pistil and stamen thinly using malachite green.

For the sepals, the joints of the stems, and the stems, use pale green and apply *fushiguma* (a fine shading) in *shōenji*.

You should repeat shading using the same color more than five times, perhaps even seven or eight times, especially when drawing a peony with delicate care.

Each of these processes can be broken down as follows:

1) Ninety percent of the inside of each individual petal should be covered with a mixture of *shōenji kime* and shell white.

2) In a darker color made by adding *shōenji*, apply the wash to seventy percent of the petal, working up from the base.

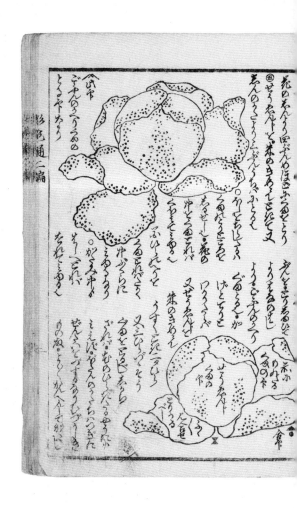

PEONIES

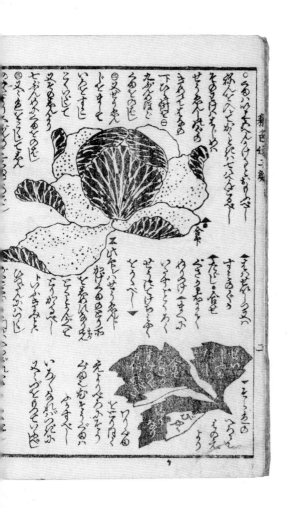

3) Darken the pigment further and apply a wash to thirty percent of the petal, working up from the base.

4) Darken the pigment even more and apply it to just forty percent of the length of the petal, working up from the base.

5) Dissolve *shōenji* further and, using the resulting vermilion *kime*, extend the tint up just thirty percent of the length of the petal, moving up from the base.

For the leaves, maybe use *seishitsu* (azure) or a mixture of *sumi* (ink) and shell white, or *awasegusa* (blended grass), a mixture of orpiment and indigo wax. As I mentioned earlier, draw the lines of veins in malachite green.

⚹ Indicates the places in which *kageguma* (shadow gradation) in *shōenji* should be applied. Please carefully consider its placement before you start.

However, all this is very difficult to explain in writing. Unless you are my pupil, it is hard for me to explain all the details to you.

Paint [the fronts of the leaves] evenly in *seishitzu*, or *awasegusa*, or a mixture of *sumi* and shell white.

Paint [the backs of the leaves] white.

Apply *wariguma* in pale Prussian blue around the base of the leaves; apply *sōguma* from the base of the leaves to the edges. There are several ways to do this, which I will explain with illustrations in the following sections.

The places where I have added dots indicate where shading should be applied using a wash (p. 102). When you apply a wash to the inside of the petal, the inside appears concave; when you apply a wash to the edges, the petals appear convex and halfway swollen; when you apply a wash from the inside to the edge, the petals looks like they are folded.

The dots indicate the places to apply shell-white *kaeriguma* (inverted gradation).

After a *shōenji* wash is applied, apply *kaeriguma* in shell white at the edges of the petal; if you understand the principles of *kage* (shadows) and *teri* (highlights), apply *sōguma* to a couple of petals using *shōenji kime*.

If you do not go through this process, the flower will not look like it is properly in bloom.

I will also explain the shape of the peony flowers. This is not easy, so please carefully consider what I write when drawing them.

▲ Indicates where shading should be applied, which I did not explain earlier.

⁑ Indicates where to apply *shōenji* shading.

⚏ Marks areas to review carefully from the beginning.

LIONS

I would like to write about something different here. In Japan, creatures' forms have been misrepresented since the ancient times. By this I mean creatures such as *qilin* (Chinese unicorns), elephants, dragons, *shōjō*,[8] sheep, and lions.

The lions' bodies I have illustrated here have the form used by various artists since the ancient times.

If you come across depictions of lions on foreign goods, such as ornamental wares, on coins, or in etchings imported by the Dutch, you will find that they look like dogs and do not appear ferocious in the least.

Among the 364 examples of animals with fur, the lion is king. Although the lions on foreign goods are depicted as seen by foreign artists, nobody here thinks they are lions. Therefore, I will reproduce their accurate form and appearance here.

I will discuss the appearance of other creatures, such as the elephant and the *shōjō*, in the next volume.

<p style="text-align:center">* * *</p>

When it comes to drawing *renzen* (chain-of-coin)[9] patterns on lions, people often draw them like the illustration, but this is not accurate. I will explain how it should be done in the illustration below. Please examine it carefully.[10]

In the *renzen* pattern, as seen in the second illustration, each fur line originates from the same central point. You should remember this concept when you are coloring.

LIGHT-COLORED LIONS

Apply yellow-ochre shading in the spaces between the *renzen* (chain-of-coin) circles; for the upper jaw, the elbows, the space between claws, and the hip joint, lightly shade using a thin wash of vermilion-based *nikushiki* (beige) from the outside in; apply a light wash of yellow-ochre *kime* (the transparent top layer) over the whole area from the head to the spine; for the eyebrow hair, whiskers, crest, spine, legs, and tail, thinly paint with a white gray and apply *kageguma* (shadow gradation) in mid-tone gray *kime*; for the belly, shade the inside with a light wash of shell white; draw narrow, shell-white hair strokes for all the furry areas, as above (pp. 110–111); add

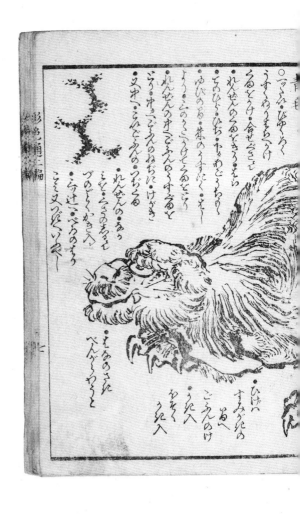

LIONS

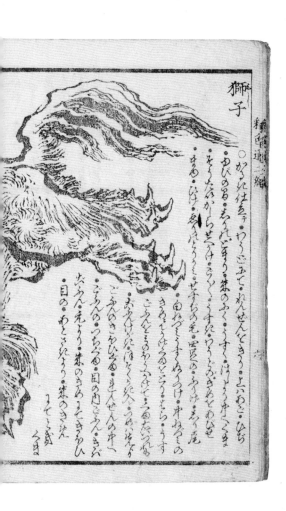

獅子

○かうべは先まづ○わうごまて○れんぜんときう○よいわう○ひらゆびの目○それよする○株のふく○くすく○けうゝいくゝせそうよはひからせうけ○らくうすたたへうよんぶあめとめひせそあ○ひげ○又とうよゝそせうちち毛○雲足のふうげ○あう尾

○白わづくこすすゆうつけ中ぬこみのこれをきものわうくよふて○面たいうくゝゝけうらうゝけるめをところくつよ○うすおんそんきゝよりくゝりくゝつめうゝ後うゝ○ほんまゝちゝよち○ごふんのきうひろめ○株のぜんゝ中へぐるんのつちうゝゝ目の内ごふんゝゝひ○目のあとさねより○株のきめゝたきうゝひ○目の内ごふんゝゝひ○だふんゝえうり○株のきめゝゝたきゝりん

そてゝゝ
くゝ

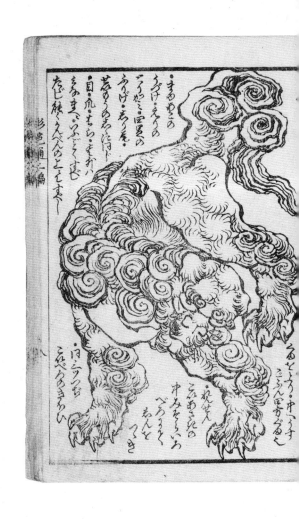

LIGHT- AND DARK-COLORED LIONS

110

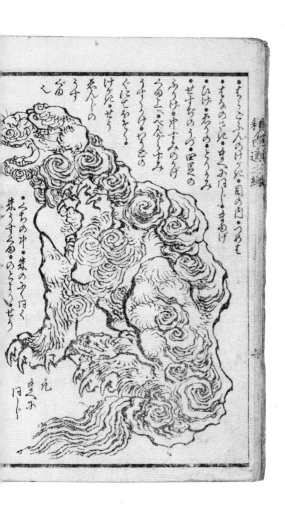

kioiguma (hints) of shell white to the tips of the claws; apply *tsujiguma* (central gradation) using shell white at the center of each *renzen* circle; use shell white for the inside of the eyes and the fangs; add *kioiguma* of vermilion *kime* around the base of the fangs; apply a light wash of vermilion *kime* around the edge of the eyes.

For the whiskers, paint narrow lines of shell white between the *sumi* (ink) lines.

Use a mixture of *bengara* (red iron oxide) and yellow ochre for the tip of the snout.

DARK BLUE-HAIRED LIONS

Paint the overall form with a thin coat of pale green; apply *kageguma* (shadow gradation) to the belly; apply a wash of *awasegusa* (blended grass) to the spaces between the *renzen* (chain-of-coin) circles; for the belly, paw pads, elbows, lower jaw, and the space between the claws, apply shading from the edges to the inside using a light wash of vermilion-based *nikushiki* (biege); apply a light wash of shell white to the inside of each *renzen* circle and draw hair strokes using shell white; also apply *tsujiguma* (central gradation) to the center of the circle using darker shell white; add thin lines radiating toward the edge of the *renzen* circles using *kioiguma* (hints) of *kusa no shiru* (essence of grass) as seen in the illustration (p. 108, top left).

Add stippling in Prussian blue to the three-forked road.[11]

BLACK-HAIRED LIONS

For the belly, paint hair strokes with shell white.

Paint the inside of the eyes, the claws, and the tip of the snout in the same fashion as above.

For the eyebrows, the whiskers, the crest, the wavy fur along the spine, and the hair on the legs, apply *kageguma* in mid-tone *sumi* (ink) topped with a thin coat of *bengara* (red iron oxide) mixed with *sumi*; draw narrow hair strokes using yellow pigment mixed with shell white, and then apply *usuguma* (a light wash) of *shōenji* (dark red).

Paint the inside of the mouth with a vermilion-based *nikushiki* (beige) and apply a vermilion *usuguma* on top; apply a wash of diluted *shōenji* to the throat.

For the most part, [coloring these lions] is the same as in the previous section.

Paint the overall form in pale blue-green *kime* (the transparent top layer); apply *mawashiguma* (outline shading) to the *renzen* (chain-of-coin) pattern in a darker pale blue green, as mentioned above; and for the inside of each circle, apply *shihōguma* (a gradation extending out from the center) using light shell white.

Use the same technique as the dark blue-haired lion when it comes to the eyebrows, the wavy fur of the jaw, the crest, the hair on the legs, and the tail.

The eyes, claws, and belly are also the same as above; however, please always consider what you do carefully.

Wash the spaces between the *renzen* circles in a darker shade of pale blue green and add thin lines radiating toward the edge of the *renzen* circles using pale Prussian blue.

Add stippling in dark Prussian blue to the spaces between the *renzen* circles.

HOW TO COLOR ANIMALS WITH FUR

Both birds and animals display specific features in the growth of feathers or fur. There are seven points where the fur swirls; there are also seven points where it divides to the left and right of the body.

Paint the lower belly and inner thigh, where the fur is thin, using *nikushiki* (beige).

The upper jaw, paw, and ear hair is short. The fur from the corner of the eyes to the inside of the ears is always thinner than the rest.

The fur on the bridge of the nose is short.

There are areas where the hairs divide left and right on the chest. Since the ancient times, some people have drawn it like this (p. 116, top left), which is not accurate.

For animals, paint the overall form in a vermilion-based *nikushiki*; paint fur lines using shell white; apply gradations in shell white to the areas where light is reflected.

Here (p. 117, rear legs) is where you should apply coarse fur lines; paint thinner yellow-ochre *kime* (the transparent top layer) throughout the area; create a gradation using a mixture of *bengara* (red iron oxide) and yellow ochre; introduce narrow lines of yellow pigment mixed with shell white between the *sumi* (ink) lines.

Please note, this form (pp. 116–117) is just an example of a typical "furry animal" to illustrate some of these details. I will explain painting tigers in detail in the next volume. This image merely illustrates the hair growth of animals with fur. I will explain the tiger, the panther, and many similar species in the next volume.[12]

WILD BOARS

As this book is for children, I will explain only the easy parts:

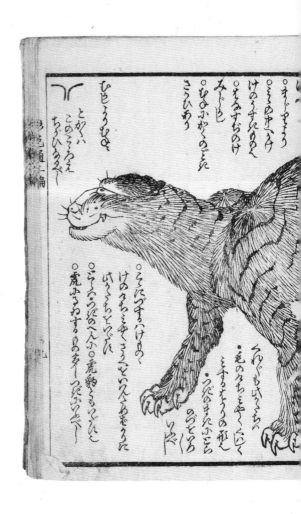

○すぢやとう
○そこ中へげ
けのすぢのく
○そみすぢのけ
みどゝ也
○むかくらのどそ
さうひあり

むとうむく
とかく
このうゝゑ
ちぢひゝろべー

○うにづすハけの
けのゝもゝやゝさう
けっちとべに
○らへうぢのへんか○虎豹ともぢんこ
○虎ふうおするの多しづゞうゞべー

○そのすぢふゐ
のそとろ

○またゝ虎のうち
光のゝちゝやくにく
をするそうゝの歴

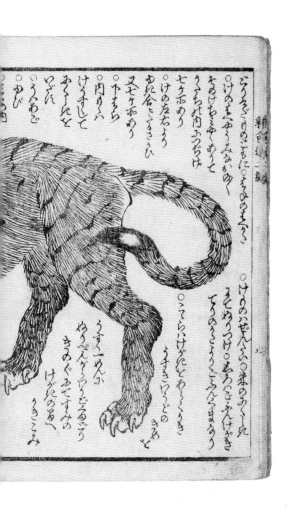

らうゑぐりのこもに
けのまゝうんゝみ
そのけもせゝゑく
うちそれ肉ふつゞけ
七ケ所あり

けの左ちより
申尼合とゝるさひ
ヌ七ケ所あり
下ちゝ
肉りく
けうましして
おくられと
のひ

らゝとのまゝゝ
そのゝゝゝち

けのハぜんべら○
うくねうつけ○おの
ちのうゝゝゝゝけぢ
ゝゝのうゝゝゝふよゝ

○ゝらゝけゞと
うすゝゝゝのきめ
と

うす一ゝふ
ゆうぶんくゝうゞるゝゞう
きゝのぐゝてすみの
けぢゝゝゝ
うきこゝみ

○うくはし
○ゆび
○うゑわぢ
○うゑわご

1) Draw outlines in *sumi* (ink), but leave space for white gradation in: the upper and lower mouth, the jaw, the belly, both thighs close to the rump, indicated by ●●, the tip of the tail, indicated by Ｉ, the fang, the hooves, the eyes, indicated by ▼, the edge of the eyes, maybe the inside of the mouth and the inside of the ears, the fur on the base of the claws, and the angular joints of the hind legs.

2) Apply *sōguma* (general shading) using light *sumi* everywhere, including the upper lips, the jaw, the belly and the inner thighs, the corner of the hind leg joints, and the inside of the ears.

3) Apply a thin coat of *kaeriguma* (inverted gradation) to the area mentioned above using vermilion-based *nikushiki* (beige); apply a light wash of dark shell white to the tip of the tail, the upper eyelids, and the shoulders.

4) Paint very thin hair strokes for the *sashige* (mixed-color coat hairs). There are many *sashige* on the belly, the inner thighs, and the tips of the hooves, so add more *sashige* lines here than in other areas. It is the same for the base of the hooves.

Paint the jaw and the upper lip with shell white.

6) [13] Again, apply shell-white gradation to the *sumi* hair strokes; apply shell-white *kaeriguma* to the ridge

of the ears; around the top of the upper eyelid, paint hair strokes in shell white; apply shell-white gradation around the base of the upper eyelid.

7) Paint the inside of the eyes shell-white; apply *usuguma* (a light wash) of vermilion *kime* (the transparent top layer) as seen in the illustration (p. 120); for the pupil, paint with dark *sumi* and add *teri* (highlights) using Prussian blue.

8) Apply shading around the spine and the knees, and from the forehead to the *ikarige* (coarse hairs from the top of the head to the back); apply a mid-tone *sumi* gradation to the snout indicated by ◑ from the narrow part to the top of the snout, as indicated by ▼; apply *kaeriguma* again to the top of the ears; apply a downward gradation with mid-tone *sumi* from the corners of the eyes to the brow bone in order to make it appear convex; for the snout and the top of the hoof, apply a light *sumi* gradation followed by a light wash of indigo; use shell white for the tusks; apply light yellow-ochre *kioiguma* (hints) around the base of the tusks; paint the teeth shell white and apply *kioiguma* of vermilion *kime* around the edges; for the whiskers and the eyebrows, paint narrow hair strokes of shell white between the narrow, dark *sumi* lines.

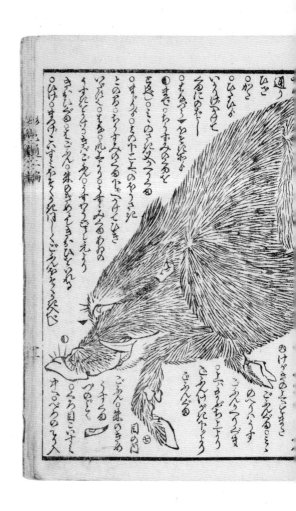

WILD BOARS

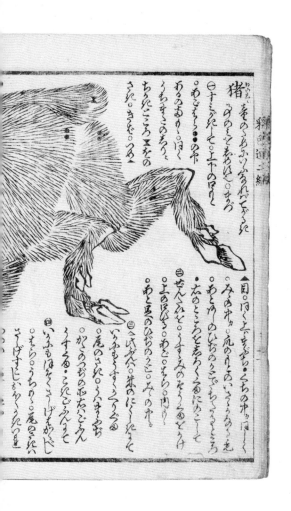

猪

〇ほくとよきますぢ・くちの中ッほしく
みゆなり・尻のうしろいろゝあるところ
〇あとのひたらのところゝいろゝうらゝ○走
○あとゝ○ところをゝすみのぞゝる
○右のところゝゝ○すゝみのぞゝゝゝゝ
〇上のほびゝ○わぢ○そゝ○肉り
〇あと足の丸・ところ○る○ゝみ○く○ゝゝゝゝ

〇せんくれを○○すゝゝのぞゝゝ○

へ尾のさくを○うまゝゝゝ
○かさのつぢのこ○丸たい○ぢゝ
すこゝゝ・こ○え○ぶゝゝ

いゝもほ○くさ・げゝゝかくじ
そ○ゝ○うゝゝ○尾○こ丸○
さげげすじ○○○○ゝゝ○つゝ

猪
葦のくれふいふ○れでぞゝゝ
○ゝのゝゝゝをあゝゝゝ○まぢ
一すゝゝゝ○○○上下の口ゝて
○あぢそゝゝ○○のゝゝ
あるゝあゝゝ○○ゝゝ
○うゝまぢこのゝゝゝ
ちゝゝゝゝゝゝゝをゝ
さゝゝ○ゝゝゝ○つゝゝ

This entry explains coloring ducks, chickens, grebes, quails, night herons, sandpipers, ibis, and pheasants.

For the small shoulder feathers, draw feather lines using *sumi* (ink), as seen in the illustration (p. 125 , right); apply a thin coat of yellow-ochre *kime* (the transparent top layer) over a gradation painted with light *sumi* from the base of the feathers toward the center; apply *sōguma* (general shading) in *shōenji* (dark red) to the highlights on top of the base of the feathers, which should be painted using a gradation of *bengara* (red iron oxide) mixed with *sumi* and applied around the base of the feathers.

For birds with white or slightly white feather tips, leave white around the feather tips, then apply yellow-ochre *kime* all over the feather. Next, apply *kaeriguma* (inverted gradation) in shell white within the feather tip, again depending on the coloring of each bird.

For doubled feathers (p. 124, bottom), apply a dark Prussian blue gradation and *wariguma* (partially colored gradation) in Prussian blue. Apply *kaeriguma* in shell white from the tip toward the center, then apply *fukashi* (a thin layer) of Prussian blue around the base.

For the rear wing feathers, apply a gradation in mid-tone *sumi* from the base toward the center; apply *wariguma*

using mid-tone *sumi*; beginning at the base of the rear wing feathers and extending over the entire form, apply gradation in a mixture of *bengara* and *sumi*; apply *kaeriguma* in shell white from the tip toward the center; apply *fukashiguma* (a thin layer of gradation) using *awasegusa* (blended grass) around the base.

For all the feathers mentioned here, *fukashiguma* or *shirukuma* (a liquid wash) of fine malachite is commonly applied; apply *shōenji* gradation or Prussian blue *fukashi* on the base, depending on the type of bird; apply gradation using yellow-ochre *kime*, *bengara* mixed with *sumi*, or *shōenji*.

The spotted pattern on the small feathers can be seen in the illustration below (p. 125, right).

Apply *sōguma*, avoiding the narrow lines between the small feathers and the doubled feathers (p. 125, left).

In the illustration below (p. 124), I describe the features of the small feathers on the rooster's shoulder. Apply *usuguma* (a light wash) using a mixture of *bengara* and *sumi* on top of light *sumi* shading and *shōenji teriguma* (highlight gradation).

Apply *sōguma* around the area of the rear wing feathers and, of course, for the flight wings.

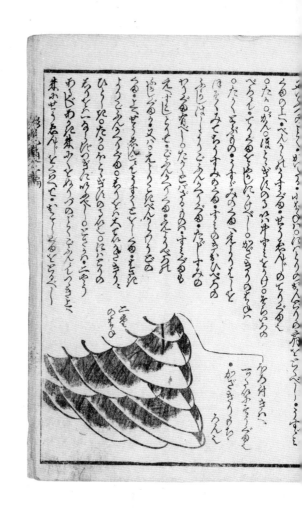

HOW TO COLOR ANIMALS WITH FEATHERS

ふぢの
のぶ
づの
ぢくらく

DETAILS ABOUT BIRDS, PHEASANTS, AND SNAKES

○かくれたるきつせんをばくらくそそく
又つぶ○此者たんをすきゆう○きぬぐゑでつつき
○せうきぬとに米とろと○おどつふとうぐ
○きはとるれ○あとをそれちかすくにたなり
C その○とをとふときり○いゆじきとうすく
なり○すみちきのるゝと○おゝんつくもり
○そうとゝうすうけ○うすてきゝれゝそこの
どくそるとろそう又うじぶろくすくそろう
○するどくどぶんろろろして半みろ○あゝとゝゝ
うけ○つのどくつのこをのどくにじぶとじどもとし
○中ねぶとんれうすものれしろ○ころろと○ころかゝ○ハ
○きのどくらつどのどくるよりこにともりじ○口歯のよぅろに
うくみるそのゝつれきこそいろろちのするゝひ
つのどく○米のきゝそのろろちゝくろのまとゝゝり
○きのろ○又とゝゝとのゝとのてあるもりで
○ろんろうろつろ○又はしのられろうとるゝ
とふろうつゑ○又はしのられろろゝ○もけてるゝでろ

For hawks, geese, and cuckoos, apply mid-tone *sumi*, and add *teriguma* using a thin layer of pale Prussian blue.

For the flight wings of high-flying birds, leave a thin white line around the edge of the feather and apply mid-tone *sumi* gradation from the base to the tip on top of a light *sumi* gradation; apply *kioiguma* (hints) of *sumi*, Prussian blue *fukashi*, and *kaeriguma* in shell white from the edge toward the center. *Wariguma* in *sumi* can be added here too.

For the flight wings of low-flying birds, apply a small *sumi* gradation around the base of the feathers, and *kaeriguma* in shell white [around the wing tip]. Maybe apply *fukashiguma* in Prussian blue, or apply a faint gradation in *shōenji* over a gradation painted in a mixture of dark *bengara* and yellow ochre on the base. Apply *kaeriguma* in shell white around the wing tip.

For most birds, such as hawks and cuckoos, the same method used for the flight wings can be applied to the tail feathers.

There are small and large pockmarks on birds' combs (p. 127, right). Here are some tips. Add dots of seven different sizes—otherwise it is not a good look. The illustration shows the correct way to add seven different dots.

When painting in lighter colors, use mainly *shōenji*, or

paint with Shōkichi-brand *tan* (red lead oxide); add dots in yellow mixed with shell white; apply *okoshiguma* (elevated wash) with a mixture of *shōenji* and vermilion on top.

For the wing tips and wattles, the technique above can be applied.

AN EXPLANATION OF BIRDS' LEGS

For yellow legs, paint thinly using *nikushiki* (beige); apply a light wash of yellow gamboge; apply shading with vermilion *kime* (the transparent top layer), as seen in the illustration.[14] Alternatively, paint thinly using pale green; paint *harikomi* (an even coat) of shell white, then top with a wash of yellow gamboge; apply *usuguma* (a light wash) with *kusa no shiru* (essence of grass) as seen in the illustration.

For muddy legs, paint using mid-tone gray; draw the cracks using *sumi* (ink) as in the illustration of the pheasant (pp. 132–133), topped with shading in a wash of *kusa no shiru*.

There are yellow or mud-colored beaks too. Paint with yellow pigment mixed with shell white from the tip to the base; apply gradation in vermilion *kime* as in the illustration; apply *kaeriguma* (inverted gradation) using shell white from the tip of the beak to the upper beak, or

apply *usuguma* with *kusa no shiru* from the base to the tip, as in the illustration, and add *kaeriguma* in shell white as mentioned above.

SNAKES

Paint the belly using pale green and apply shell white evenly inside the *sumi* (ink) lines; on top, apply a wash of *shōenji* (dark red) *kime* (the transparent top layer) mixed with a little shell white; apply *kageguma* (shadow gradation) along the shadows of the curve.

For the back, paint the central stripe and *zenigata* (coin-shaped) pattern in dark *sumi*, using the side of the brush. Shade only the edge of the *zenigata* pattern.

Apply a thin wash of yellow-ochre *kime* to the entire form; apply a *bengara* (red iron oxide) gradation to the spine, avoiding the side of the belly. For the side of the belly, apply a thin coat of yellow gamboge on top of yellow ochre; add stippling using shell white. As in the illustration (p. 127, left), draw a *togari* (triangle) pattern in *sumi* on the side belly and beside it apply dark vermilion *kime*; apply *kioiguma* (hints) of *kusa no shiru* (essence of grass) between the *sumi* contours of the side of the belly.

Inside the hexagonal area on the head, apply *shihōguma* (a gradation extending out from the center) using light

sumi; apply a light *sumi* gradation from the base of the mouth to the neck; apply *wariguma* (partially colored gradation) in light *sumi* from the head toward the body; apply a mixture of *bengara* and *sumi* in the same fashion as on the back; for the lower jaw, use the same method as the side belly; paint with vermilion *kime*; apply outline shading using *shōenji* for the eyes; paint the pupils in *harikomi* (an even coat) of Prussian blue.

Look carefully at the illustration (pp. 132–133).

PHEASANTS

The dots indicate the area of gradation on the pheasant's feathers (p. 126). Apply *wariguma* (partially colored gradation) in light *sumi* (ink).

Paint a mixture of *bengara* (red iron oxide) and *sumi* from the edge of the pheasant's tail toward the inside.

Paint a thin coat of pale green from the back to the base of the tail; apply a gradation in a mixture of *bengara* and *sumi* from the upper tail toward the upper body.

Paint the edge of the tail with *bengara*, mixing in *sumi* toward the tip of the tail; add gradation from the edge toward the inside.

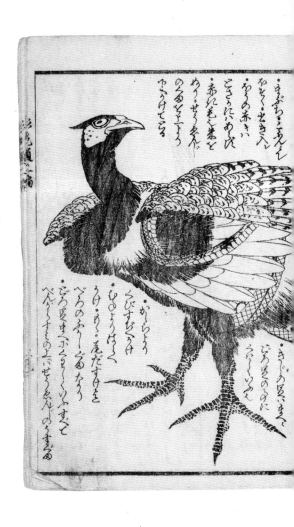

PHEASANTS AND SNAKES

雛子

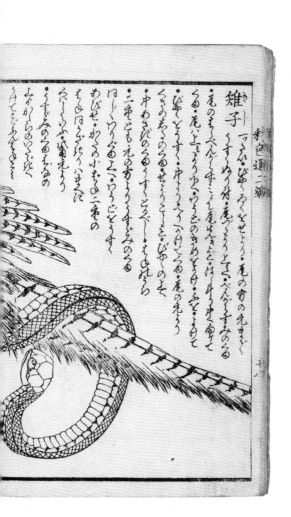

For the tail, apply yellow *kime* (the transparent top layer); apply a thin white gradation from the inside toward the edge, avoiding the spotted pattern.

Apply a *kusa no shiru* (essence of grass) gradation on the base of the tail.

Paint the area from the back to the bottom white; apply a top layer of shading using a light wash of mid-tone pale yellow green.

For the backs of the feathers and the double feathers, apply a light *sumi* gradation around the base; apply *wariguma* using light *sumi* toward the top and apply a light wash of yellow ochre over that.

For the small feathers on the shoulders, the double feathers, and flight wings, details are explained on the previous page.

Apply a light *sumi* gradation and add shell white from the tip of the beak to the crown of the head.

Treat the inside of the eyes the same as chickens' eyes. Draw a narrow line of shell white around the outside of the eyes.

Red cheeks are not like a chicken's comb but like a red feather. Paint them vermilion and apply a downward gradation in *shōenji* from the top to the bottom.

Details for painting the snake were explained on the previous page.

For the pheasant's legs, details are in the section about muddy legs. In all cases, apply *usuguma* (a light wash) of *shōenji* on top of a mixture of *bengara* and *sumi*.

Apply *fukashiguma* (a thin layer of gradation) from the head to the neck, from the chest to the belly, and from the thigh to the rump.

HAWKS

For hawks, draw the outlines in *sumi* (ink) as shown in the illustration (pp. 138–139). However, for the small feathers, add blurred lines using dark *sumi* and the side of the brush.

Add gradations of light *sumi* to the double feathers, the rear wing feathers, the flight wings, and the tail; then, on top of that, apply another gradation in mid-tone *sumi* that extends out from the edge.

For the back side of open wings, apply a gradation with a very thin coat of light *sumi*, as on the front side. This should be applied very thinly. Often people paint a darker gradation than necessary. Please pay attention when applying gradation.

From the base of the open wings to the belly, apply *sōguma* (general shading) using light *sumi*.

Apply *damiguma* (a covering wash) in mid-tone *sumi* over the small feathers on the back; apply *kioiguma* (hints) of darker mid-tone *sumi* to the neck and the left side of the shoulder.

To draw the spotted pattern on the belly, use mid-tone *sumi*.

Apply *fukashiguma* (a thin layer of gradation) using whitish gray mixed with shell white from the chest to the belly and from the back side of the open wings to above the chest, avoiding the throat.

Apply an upward *fukashiguma* diagonally from below the beak toward the top using the same whitish gray.

Hawks are difficult to paint. Don't assume you will understand immediately. Please consider very carefully.

Apply *harikomi* (an even coat) of mid-tone Prussian blue for the inside of the pupils.

Apply a gradation of *kusa no shiru* (essence of grass) for the highlight of the eyes.

Apply *sōguma*, using a thin layer of mid-tone *sumi*, from the base to the tip of the rear wing feathers.

Apply the same gradation from the base to the top of the flight wings.

For the tail, apply the same gradation from the base to the tip, leaving narrow white lines as seen in the illustration (p. 138).

Apply *fukashiguma* in pale Prussian blue for the left and right shoulders, the neck, the base of the tail, and the base of the flight wings.

For the insides of the eyes and legs, see the details mentioned in the entry for chickens.

Use yellow mixed with shell white for the beak.

Use shell white for the area above the nostril.

Apply *usuguma* (a light wash) in yellow gamboge, avoiding the rim of the nostril.

For the eyes, apply yellow gamboge thinly over a base of yellow mixed with shell white.

Apply *mawashiguma* (outline shading) in *shōenji* to the area around the eyes.

Use Prussian blue for the pupils.

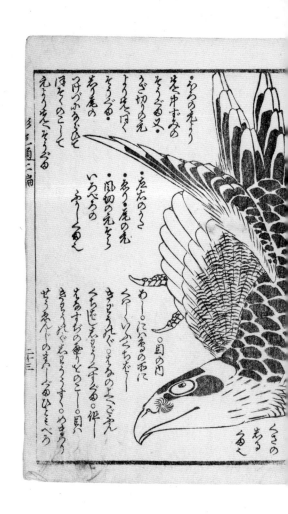

・やろの尾より
冬、中ずみの
そろづぬ又・
ゝご切りの元
より先へつく
そうづぬ・
そり尾の
つけづふるひて
ほそのこゝして
ゑうり先へそうづぬ

・左右のうら
・多うき尾の元
・間切の元そろ
いろべろの
ふうくゑく

・わー・にへうきの花に
へうーくいろくちだー
きゞとそれぐ・そうぬの上ごぶん
くらじにそううくうするゝ・伴ー
そうすぢの香りとのこと・貝
きろうぐれぐゝろうろうす・ゑうう
せろゑんじのまーづぬひとくべろ

○目の内

くきの
ある
うく

二十三

HAWKS

138

鷹　○たかすへだにづめ（で）ぐちくとら

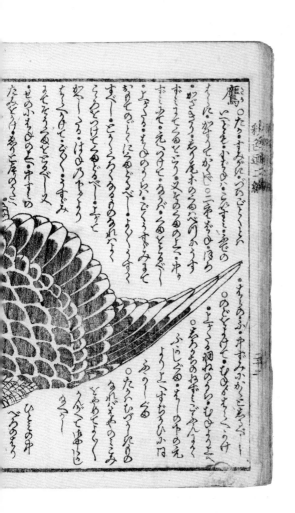

The quality of these products has become incredibly bad with the passage of time. They contain precipitates—you will find white dregs in them.

Hirosuki, *senbon*, and *ichimanbon*[15] are greasy. They look like shiny crystals, but oil must be removed from them.

Soak solid animal glues in water for one day and night in the winter and spring, and for one day in the summer and autumn. When the oil has separated and is floating on the surface of the water, wash thoroughly and boil the raw material.

A high-quality glue is less oily, but it sometimes contains dirty dregs. You should always filter it through paper.

To use animal glue of either good or bad quality, distill it with a *ranbiki*.[16]

Imported *ranbiki*[17] are not made of clay. They will be damaged if used for distilling animal glue.

Instead, sake bottles can be used to make an instant *ranbiki*. Detailed instructions follow.

Put the animal glue into a sake bottle with a neck. Take a sake bottle without a neck and, as in the illustration

(p. 142, center), join the mouths of the two sake bottles and tape tightly to prevent air leakage.

To make the tape, mix udon noodle flour and calcium carbonate with water, and paint the mixture on a thin piece of cloth. Then tightly wrap the cloth around the joined necks of the two bottles.

[Heat the *ranbiki* as illustrated (p. 142, bottom).] When the animal glue is boiling rapidly, its steam will travel to the bottle without the neck. When the bottle with the neck is shaking, peel off the tape, separate the two bottles, and transfer the glue condensed inside to another container.[18]

By the way, distilling *suterekiwaatoru* (nitric acid), commonly called "the way of *kusarakashi* (corroding)," uses the same technique. This makes it easier to produce Dutch-style copperplate engravings.

There are three different raw materials: alum (10 *monme*), melanterite (10 *monme*), and chalcanthite (25 *monme*).

Put the three ingredients into the bottle with the long neck and, as mentioned earlier, join it to a bottle without a neck using tape, as illustrated. When the material is boiling, the steam will flow to the bottle without a neck. The bottle with the neck will become as hot as the flame.

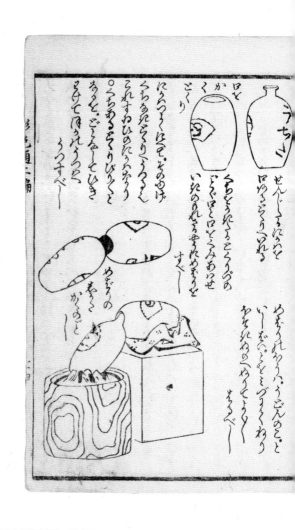

ABOUT ANIMAL GLUE

○にくのゆをとゆふ・ひうゝとりせんさくはゆゝぎわ〳〵なりて
れどむところをうきかすとらぐひ・ひろまき・ふぜん一まんびん
ありうほうく・とかけるゆ一〳〵れとぐを・そのゝぶ〳〵とぐるぞじ
ふゝるゝ八一ゆちうちゃ・おつわきゝ八一ゝち・みづふほをめくその
わぐぐるゆくとゝるぜてらゝとぎゃく〳〵わ〳〵ひてぜん〳〵じ
りゝゆべ一・上すれ〳〵わぐ〳〵ろゝそがすれきゝゝゆにゝその
ありかゝふくおゝ〳〵とりゝゆ㐂一・にうぜんわくゝ〳〵をよ
らゝびゝ〳〵くりゝゝゝゆるうぐきう・りゝ〳〵ゝゝろの
らゝびゝへすゝゝをりゝせぐれゞらゝびゝのゝふ〳〵をゝゝゝ
べ一・ぞくやにゝそ〳〵ざらゝびゝゝとゝらゝ〳〵とゝるべ一・その
いゝゝゝゝゝでゝゝゝ〳〵〳〵

When the bottles are hot, remove them from the heat and allow them to cool. Remove the tape and separate the bottles, and a yellowish smoke will come out of the bottle.

If you come into contact with this smoke, you will get sores on your eyes, nose, mouth, hands, and feet.

A pure liquid will condense in the bottle without the neck. It must be transferred quickly into a flask or glass jar. If you leave it as is, it will leak and any mats beneath the bottle will corrode.

Translator's Notes

1 The book was published in 1848, when Hokusai was eighty-nine years old. The preface was written in 1847.

2 The fifteen volumes of *Hokusai manga* are Hokusai's most popular series of illustrated books. The first volume was published by the Nagoya publisher Eirakuya Tōshirō in 1814, and it proved so popular that the Eirakuya firm, in collaboration with publishers in Edo (Tokyo), eventually produced a total of fifteen *Hokusai manga* volumes, the last appearing in 1878, thirty years after Hokusai's death. When *All about Painting in Color* was published, in 1848, the *manga* series had twelve volumes.

3 Ishizuka Hōkaishi (1799–1861), a scholar in the late Edo period and a collector of miscellaneous books, enjoyed a close relationship with popular writers such as Ryūtei Tanehiko (1783–1842) and Santō Kyōden (1761–1816), who were also on good terms with Hokusai. Hōkaishi published numerous books about kabuki theaters and the Yoshiwara brothel district.

4 A type of *washi* paper produced without adding any glues.

5 A pigment obtained from hematite. More recently, iron sulfate has been used as a substitute. See Ikuo Hirayama and Tokyo University of the Arts, eds., *An Illustrated Dictionary of Japanese-Style Painting Terminology* (Tokyo: Tokyo Bijutsu, 2010), p. 43.

6 A mixture of sappanwood dye and shell white.

7 As Hokusai mentions later, *shōenji* pigment is sold in a dry form. When pure *shōenji* is dissolved, the color is dark. It is usually diluted before being used in painting. Hokusai suggests using the darker, undiluted pigment when painting thick joints.

8 An imaginary, orangutan-like animal in China.

9 The pattern looks like a chain of coins. This pattern is also often used to depict horses' coats.

10 Hokusai's *renzen* pattern illustrations appear alongside the entry on cicadas, which is not included in this volume.

11 The spaces between the concentric circles that make up the *renzen* pattern. Hokusai called these interstices the "three-forked road."

12 Although Hokusai said he would explain how to illustrate tigers in the next volume, the production ended with volumes one and two. Additional volumes were never published.

13 The original text skips point five.

14 The "Birds' Legs" illustrations accompany Hokusai's chicken entry, which is not included in this volume.

15 Types of animal glue.

16 A piece of equipment used to distill sake, spices, and medical herbs. The name is derived from the Portuguese word *alambique*, which refers to an alchemical still with a similar form.

17 Most imported *ranbiki* are made of glass.

18 This condensation acts as a water-based animal glue.

Advertisements from the 1880s

Katsushika Hokusai's Model Book (*Tōshisen Ehon gogon-zekku*)
Published with patterned satin covers, complete in two volumes
Net price: one yen eighty sen

This book was published from an authentic manuscript of images permeated with the creative spirit of Master Katsushika Hokusai's later years. That means it is full of human figures, birds, and beasts, all illustrated as if actually alive. If you have a passionate desire to study the arts, please purchase a copy of this book to see just how extraordinary it is.

Master Katsushika Hokusai's Model Book (*Tōshisen Ehon gogon-zekku*)
A beautiful book printed on *masamegami*[2] with patterned satin covers, complete in two volumes
Net price: two yen
Weight: seventy-two *monme*

This complete volume of *Master Katsushika Hokusai's Model Book* was published from an authentic manuscript of images permeated with the creative spirit of Master Katsushika Hokusai's later years. That means

it is full of human figures, birds, and beasts, all illustrated as if actually alive. Thus far already several thousand copies have been ordered and exported for sale abroad. Anyone with a passionate desire to study art, to become a craftsperson who sculpts or engraves objects, or to export their work abroad for great profit should purchase a copy of this book to see just how extraordinary it is.

ADVERTISEMENT FOR YOSHIZAWA'S STORE, 1888

We will purchase every kind of *surimono* (privately commissioned print): those devoted to haikai, those marking an actor's or artist's name change, etc. For prints bearing beautiful images, we are willing to offer high prices.

We will purchase every kind of pictorial material by Katsushika Hokusai: hanging scrolls, hand scrolls, albums, screens, framed pictures, rolled-up preparatory drawings, and prints. We are willing to offer high prices.

For ukiyo-e prints depicting beauties and the customs of former times in hanging-scroll, hand-scroll, or album format—especially those bearing beautiful images—we are willing to offer high prices.

We buy vintage postage stamps and postcards but only those no longer in use. We offer from 3 to 155 yen for various one-hundred-stamp sheets.

All of the materials listed above currently command high prices due to increased demand from abroad. Please bring us your works before that interest wanes. As more material flows abroad, prices will fall. Once the foreign markets have been satisfied, prices will return to their previous low levels, and these items will be of little value once again.

Suzuki Harunobu • Koryūsai • Utagawa Toyoharu • Hishikawa Moronobu • Nishikawa Sukenobu • Katsushika Hokusai • Miyagawa Chōshun • Nishimura Shigenaga (Senkadō) • Okumura Masanobu • Kondō Kiyoharu • Ishikawa Toyonobu (alternatively "Shūha") • Torii Kiyonobu • Torii Kiyomasu • Torii Kiyonaga • Tomikawa Fusanobu • Kitao Shigemasa (Kōsuisai) • Kitao Masanobu (Rissai) • Kitao Masayoshi (Kuwagata Keisai) • Katsu Shunchō • Shunzan • Hosoda Eishi (Chōbunsai) • Ippitsusai Bunchō • Kubo Shunman • Katsukawa Shunshō • Masunobu • Sharaku • Utagawa Toyohiro (Ichiryūsai) • Kitagawa Utamaro • Tsukioka Settei

In addition to the above artists, who are all from the Kyōhō through the Bunka periods,[3] there are numerous good, old pictures by other ukiyo-e masters.

We purchase illustrated books printed in color and brush paintings—namely hanging scrolls, hand scrolls, albums, screens, etc. No matter how many or how few items you have, please send us a postcard describing them, and we will buy them for a high price. We will even reimburse you for the cost of the postcard.

Kanda ward, Konya, fifth banchi
Imagawabashi matsuya no mukaiyoko-chō
Mr. Yoshizawa's shop, exporter of sundry goods

Translator's Notes

1 The publisher Sūzanbō's catalogue of publications includes two entries for Hokusai's model book *Tōshisen Ehon gogon-zekku*, on pp. 61 and 81–82. For the complete catalogue, see http://dl.ndl.go.jp/info: ndljp/pid/897204.

2 *Mesamegami* is a thick *washi* (a type of Japanese paper) made from the inner bark of the *kōzo* (paper mulberry) plant. It was often used in printmaking; in book production, its use was restricted to deluxe editions of illustrated books (*ehon* and *gafu*).

3 These periods cover the years from approximately 1716 to 1818.

Manabu Ikeda and Ryoko Matsuba in Conversation

RM What does Hokusai mean to you?

MI For me, Hokusai is one of the great world-renowned artists. Even though 150 years have passed since he was active, his innovative ideas and the playfulness and humor found in his pictures still have an influence on us today. We can think of him, in many ways, as one of the founders of modern art.

RM Your piece *Foretoken* (2008) has many compositional similarities to Hokusai's *Great Wave* (c. 1830–1832). Could you tell us how Hokusai's work influenced you?

MI While painting *Foretoken*, I had no intention of making an association with *The Great Wave*; the similarities are rather something that came about as a strange coincidence. My style of drawing involves starting a piece without drafting the overall composition, and in this case, I started drawing onto the three panels from the bottom, with the idea of a scene of snow and ice as a thematic guide. During the two years it took to produce the painting, however, the theme of the work gradually developed, so what was at first just snow and ice gradually became entwined with chemicals, bones, and environmental issues. Eventually, the form became a large, complex, tsunami-like mass in motion, a complex entanglement of nature and civilization. Because I was working in a small, six-tatami-mat room, it was difficult to look at the entire composition from a distance, and

it wasn't until it was nearly complete that I got a sense of how oppressive and suffocating the composition as a whole was. I then added one more panel on the left to expand the space to improve the balance. It was only then that I realized the shape of this painting had a similarity to Hokusai's *Great Wave*. I had long admired the dynamic nature of Hokusai's composition, and it became clear that this was the only way to improve my painting. I was once again reminded of just how perfectly Hokusai's works are composed. My own painting took two years to produce, but it was only at the end that this particular composition unexpectedly emerged. Thinking back, you could perhaps say that I was guided by a mysterious force, led to this work by Hokusai himself.

RM What is Hokusai's legacy for contemporary art worldwide?

MI I am not sure about that.

RM If Hokusai were alive today, what kind of artistic activities do you think he would be involved in?

MI There are several possibilities we can imagine: Would he be working in a variety of genres, like Picasso? Would he perhaps become a film director, involved in all aspects of production, like dealing with storyboards, writing, directing, and composing music?

RM Do you think that Hokusai is an "artist's artist"? If so, that would mean many artists have taken inspiration from him, but why do you think that is?

MI I don't think he is an artist only for artists. Hokusai's art has been appreciated by both a wider public and by artists, and it is the depth his works possess, something that can be thought about and enjoyed from a variety of different perspectives, that I find so incredible. From an artistic point of view, I think because creativity—that most fundamental element for those working in expressive fields—finds form in his work and is so strongly conveyed to the observer, many artists are keenly impacted by the works of Hokusai.

ACKNOWLEDGMENTS

In April 2016, I joined the three-year Arts and Humanities Research Council–funded project "Late Hokusai: Thought, Technique, Society," which was led by Tim Clark, then Head of the Japanese Section at the British Museum, and Angus Lockyer, then Lecturer in the History of Japan at SOAS University of London. That project led to the major British Museum exhibition *Hokusai: Beyond the Great Wave* in 2017. As a core project member, I organized regular Skype study sessions during which we transcribed and translated the prefaces of selected Hokusai books and some of his surviving letters, in collaboration with colleagues from Ritsumeikan, Gakushūin, and Osaka Universities. In this volume, the texts from *Modern Designs for Combs and Tobacco Pipes*, *One Hundred Views of Mount Fuji*, the preface to *Katsushika's New Pattern Book*, and the two prefaces from *All about Painting in Color* are based on the work of the study group and preliminary translations by Tim Clark and Alfred Haft. I revisited the original Hokusai texts to check these translations and added my own translations of the other texts included in this volume. Any translation errors in this volume are my own.

I am thankful for the support and guidance provided by Tim Clark and Angus Lockyer. I am also grateful for the invaluable contributions of my colleagues in Japan: Arata Shimao, Mamiko Ito, Murasaki Fujisawa, Mai Nakazawa, Ran Kamiya, Sayako Seki, Ayaka Imamura,

Sumiko Hasui, Mayu Ideguchi, Sunhui Cho, Ryō Akama, Takaaki Kaneko, Riku Tōno, Yūko Kawauchi, Yoshitaka Yamamoto, Tomoyo Arisawa, Manami Nakamura, and Hanae Hirai; my thanks also goes to the "Late Hokusai" project members Alfred Haft, Dominic Oldman, Stephanie Santschi, Koto Sadamura, and Roger Keyes. I am grateful to Janice Katz and Sarah Thompson for sharing and providing Hokusai materials very promptly. I would very much like to thank the artist Manabu Ikeda for speaking with me and allowing me include his wonderful work *Foretoken* in this volume. The Sainsbury Institute for the Study of Japanese Arts and Cultures and the University of East Anglia supported my work on this volume. I am also grateful to Peter and Faith Coolidge and Nicole Coolidge Rousmaniere for their support, and to Ellis Tinios and Oscar Wrenn for checking my translations and providing a nuanced understanding of the English text. Finally, I would like to express special thanks to Jessica Palinski at David Zwirner Books, for her enthusiasm and patience, and her respect for Hokusai's art and his words.

Ryoko Matsuba

ORIGINAL PUBLICATION INFORMATION

Modern Designs for Combs and Tobacco Pipes was first published in the Japanese as *Imayō sekkin hinagata* by Nishimuraya Yohachi in 1823.

One Hundred Views of Mount Fuji was first published in the Japanese as *Fugaku hyakkei* by Nishimuraya Yohachi in 1834 (Volume 1) and 1835 (Volume 2), and by Eirakuya Tōshirō around 1849 (Volume 3).

Katsushika's New Pattern Book was first published in the Japanese as *Katsushika ehon, Shinhinagata* by Kobayashi Shinbei in 1836.

All about Painting in Color: An Illustrated Book was first published in the Japanese as *Ehon saishikitsū* by Yamaguchiya Tōbei in 1848.

Catalogue of Publications Issued by Sūzanbō was first published in the Japanese as *Kaisei Sūzanbō hatsuda shomoku* in 1891. First published in English in Ellis Tinios, "A Neglected Book by Hokusai: Ehon Tōshisen gogon zekku of 1880," *Print Quarterly* (March 2020), pp. 29–41.

The 1888 advertisement for Yoshizawa's Store was translated for this volume from a photograph in Nagata Seiji, *Siryō ni yoru kindai ukiyo-e jijō* (Tokyo: Sansaisha, 1992), pp. 93–94.

KATSUSHIKA HOKUSAI (1760–1849) was born in Edo (present-day Tokyo), Japan, and was known by at least thirty names during his lifetime. In 1798, he declared his artistic independence and officially adopted the name "Hokusai." From that point until his death, he worked in three distinct formats: single-sheet prints, book illustrations, and multicolor paintings. In around 1831, when he was in his early seventies, he produced his most celebrated print series, *Thirty-Six Views of Mount Fuji*, which includes *The Great Wave*, the artwork for which he is best known. Shortly after completing this body of work, he published his illustrated masterpiece *One Hundred Views of Mount Fuji*. He also produced the fifteen-volume collection *Hokusai manga*, a collection of nearly 4,000 sketches that some consider the precedent to modern *manga*, though it is quite different from the story-based style of *manga* popular today. Numerous impressions of these works are in public and private collections outside of Japan, and Hokusai's rich artistic legacy continues to draw attention and admiration around the world.

RYOKO MATSUBA is a specialist in Edo-period print culture. She is currently a lecturer in Japanese Digital Arts and Humanities at the Sainsbury Institute for the Study of Japanese Arts and Cultures, University of East Anglia. She was a curatorial contributor to two major exhibitions at the British Museum: *Hokusai: Beyond the Great Wave* (2017) and *The Citi Exhibition: Manga* (2019), for which she coauthored the exhibition catalogue. She is also coordinating a joint project between the Art Research Center, Ritsumeikan University, and the Sainsbury Institute to create a comprehensive digital archive of collections of Japanese paintings, prints, illustrated books, and decorative arts in the United Kingdom.

THE *EKPHRASIS* SERIES

"Ekphrasis" is traditionally defined as the literary representation of a work of visual art. One of the oldest forms of writing, it originated in ancient Greece, where it referred to the practice and skill of presenting artworks through vivid, highly detailed accounts. Today, "ekphrasis" is more openly interpreted as one art form, whether it be writing, visual art, music, or film, that is used to define and describe another art form, in order to bring to an audience the experiential and visceral impact of the subject.

The *ekphrasis* series from David Zwirner Books is dedicated to publishing rare, out-of-print, and newly commissioned texts as accessible paperback volumes. It is part of David Zwirner Books's ongoing effort to publish new and surprising pieces of writing on visual culture.

OTHER TITLES IN THE *EKPHRASIS* SERIES

Mad about Painting
Katsushika Hokusai

Published by
David Zwirner Books
529 West 20th Street, 2nd Floor
New York, New York 10011
+ 1 212 727 2070
davidzwirnerbooks.com

Project Editor: Jessica Palinski
Proofreaders: Richard Koss,
Chris Peterson
Design: Michael Dyer / Remake
Production Manager: Luke Chase
Color separations: VeronaLibri,
Verona
Printing: VeronaLibri, Verona

Typeface: Arnhem
Paper: Holmen Book Cream, 80 gsm

Publication © 2023
David Zwirner Books

Introduction © 2023 Ryoko Matsuba

Manabu Ikeda and Ryoko Matsuba
in Conversation © 2023 Manabu
Ikeda and Ryoko Matsuba

The texts on pp. 37 and 41 were
translated from the Japanese by
Alfred Haft. Translation © 2023
Alfred Haft

The text on p. 95 was translated
from the Japanese by Tim Clark.
Translation © 2023 Tim Clark

The remaining texts in this volume
were translated from the Japanese
by Ryoko Matsuba. Translation
© 2023 Ryoko Matsuba

Image on p. 18 © IKEDA Manabu.
Photo by Yasuhide Kuge
Images on pp. 5, 14, 44–45, 52–53,
58–59, 64–65, 68–69, 72–73, 76–77,
82–83, 86–87 courtesy The
Metropolitan Museum of Art
Images on pp. 102–103, 108–109,
110–111, 116–117, 120–121, 124–
125, 126–127, 132–133, 138–139, 142–
143 courtesy The Art Institute
of Chicago

ISBN 978-1-64423-087-9

Library of Congress
Control Number: 2022920140

Printed in Italy

David Zwirner Books

ekphrasis